CUTE CHIBI

Creature Coloring

COLOR OVER 60 ADORABLE CREATURES

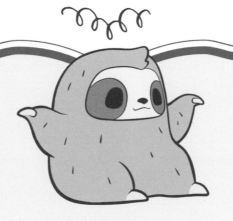

ILLUSTRATED BY PHOEBE IM

ROCK
POINT

Get your cute on!

You might have first noticed a chibi or two while watching anime or reading manga. Chibi is a style of art born out of Japan that loosely translated, means "short and chubby." Chibi characters are most identifiable by their large heads and tiny bodies, both of which contribute to their cuteness factor. You'll recognize chibis as caricatures of regular anime characters or animals, but stumpy, just a little chubby, and incredibly sweet. They are often used as a bit of comic relief when things start to get too serious, which is exactly what we need in our stressful and demanding lives.

If you're looking for cuteness overload, illustrator Phoebe Im invites you to take an adorable journey away from the pressures of reality and dive into a world of whimsy and charm. Escape from the real world and have a blast with critters doing fun activities like snorkeling and magic, indulge in delightful desserts, romp with creatures wearing costumes of their own favorite animals, obsess over plants and flowers, and explore the mysterious world of unicorns and mythical creatures. Want to know the best part? Your imagination brings it all to life with your favorite colors!

Ditch the stress and get coloring!

It's now widely known that coloring is a great way to reduce stress, improve focus, and boost creativity. Adults who color have reported a range of positive benefits, from better sleep to reducing anxiety. It's been shown to improve motor skills and lift negative moods, as well as increase mindfulness. Even just the act of choosing your color pallet can bring you into a creative space that may have been long neglected, while working within the lines (or out!) can take the stress and guesswork out of tapping into the artist within and lead you to a meditative state.

Coloring at any time will help you achieve these goals, but creating a routine is most beneficial. Try setting aside a set amount of time to dedicate to this book before you go to bed. This will help relax your mind and take you away from your screen, be it television, phone, tablet, or computer. If your days tend to be busy with little time to think, grab a cup of your favorite coffee or tea and begin your morning with a few minutes of meditative coloring to set a calm and collected tone to the rest of your day.

Cute Chibi Creature Coloring is designed to pull your racing mind away from traffic jams, your demanding boss, the anxiety of too much screen time, or any of the daily stresses we face in our adult lives, and step into a world of your own creativity. So, grab your colored pencils, crayons, or markers, unwind, and get coloring!

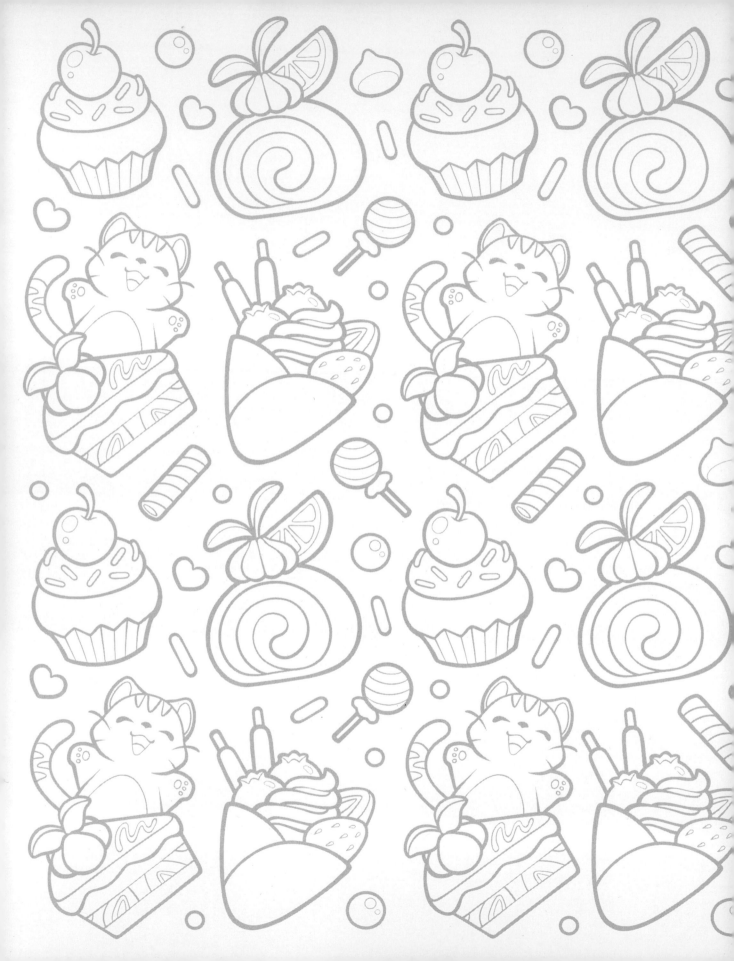

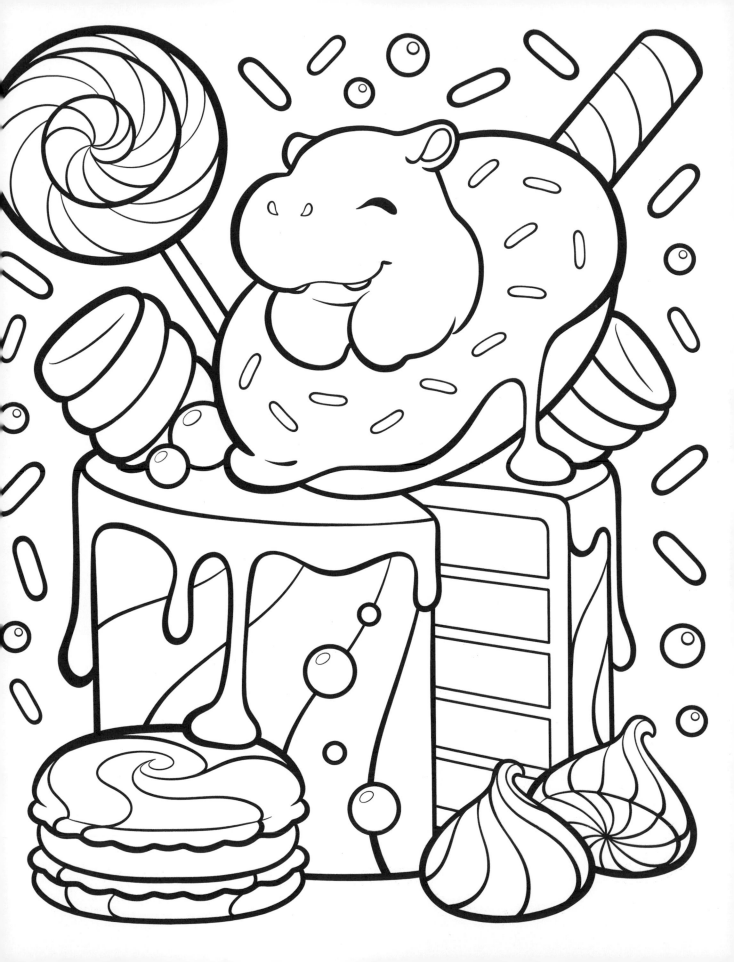

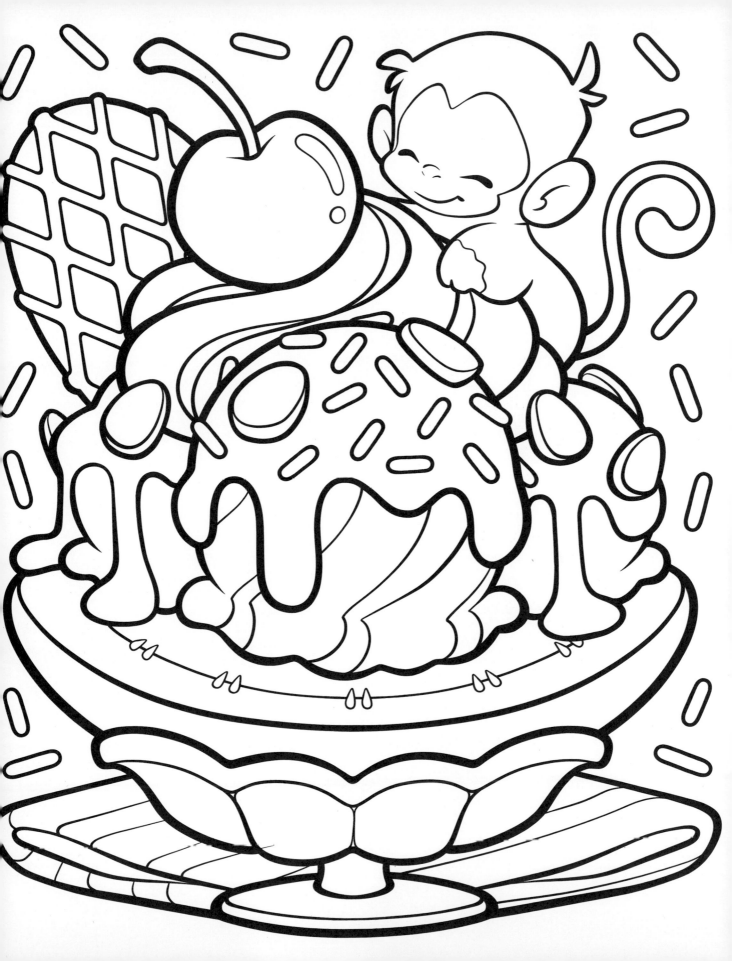

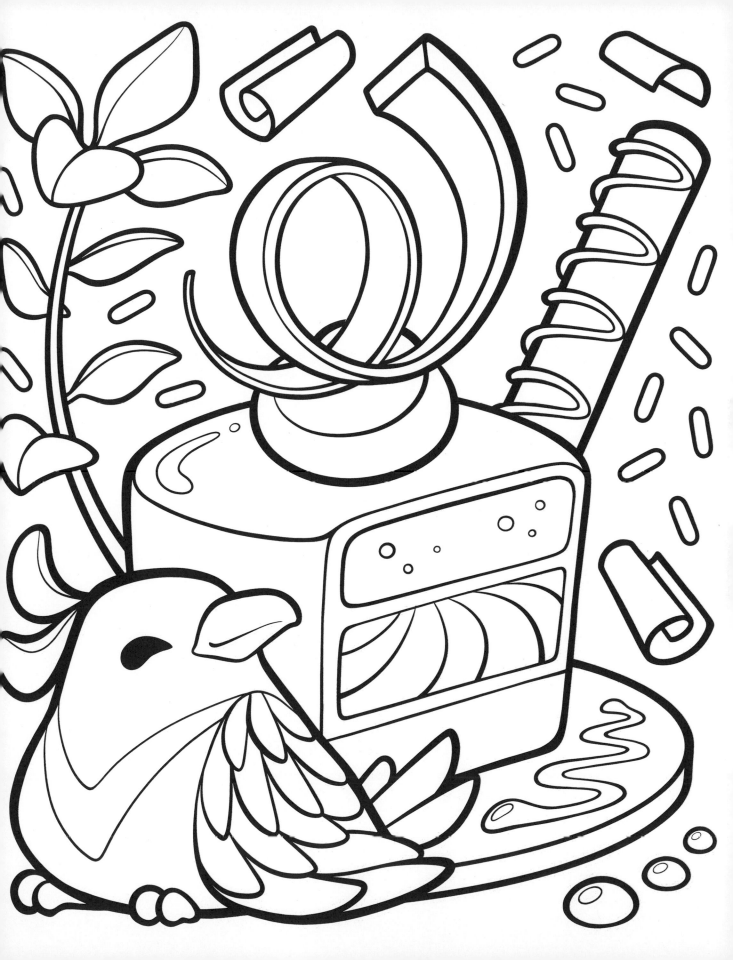

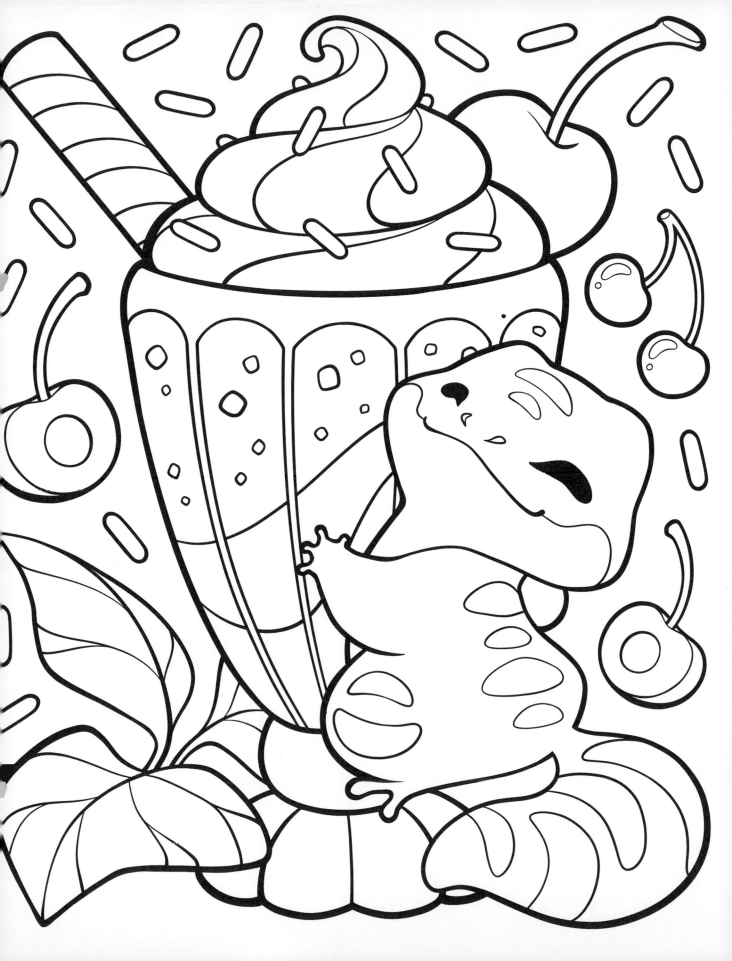

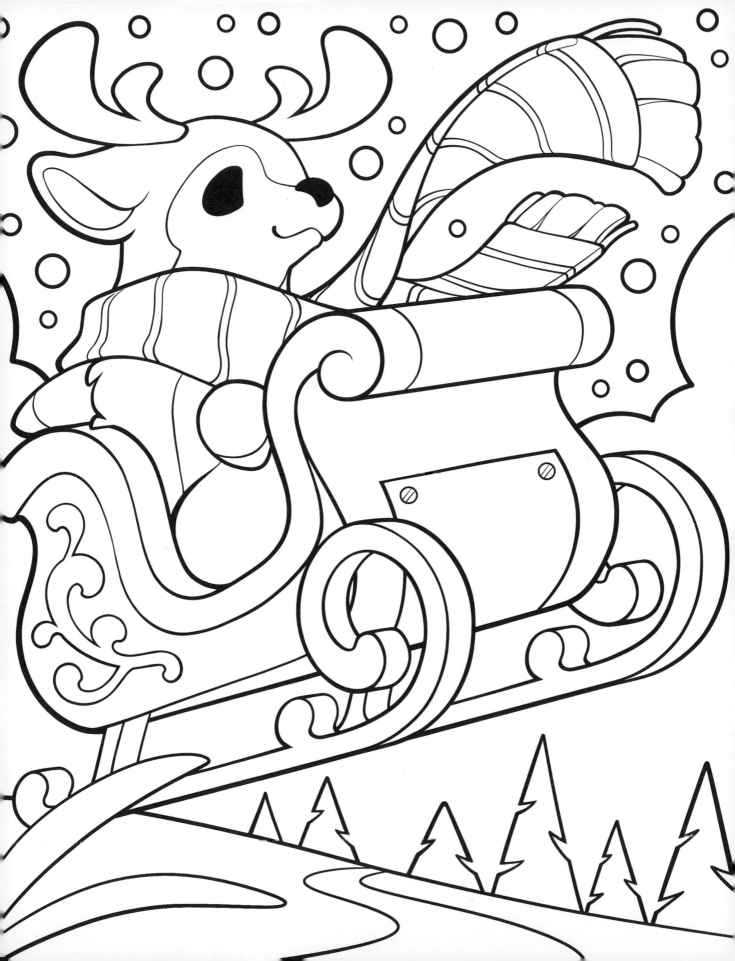

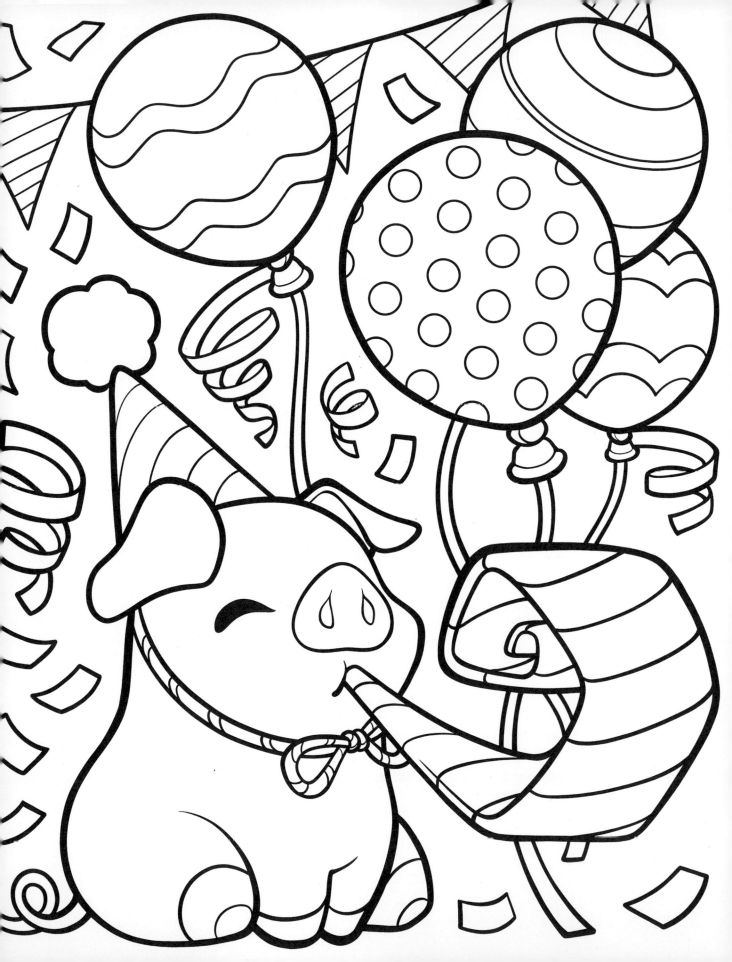

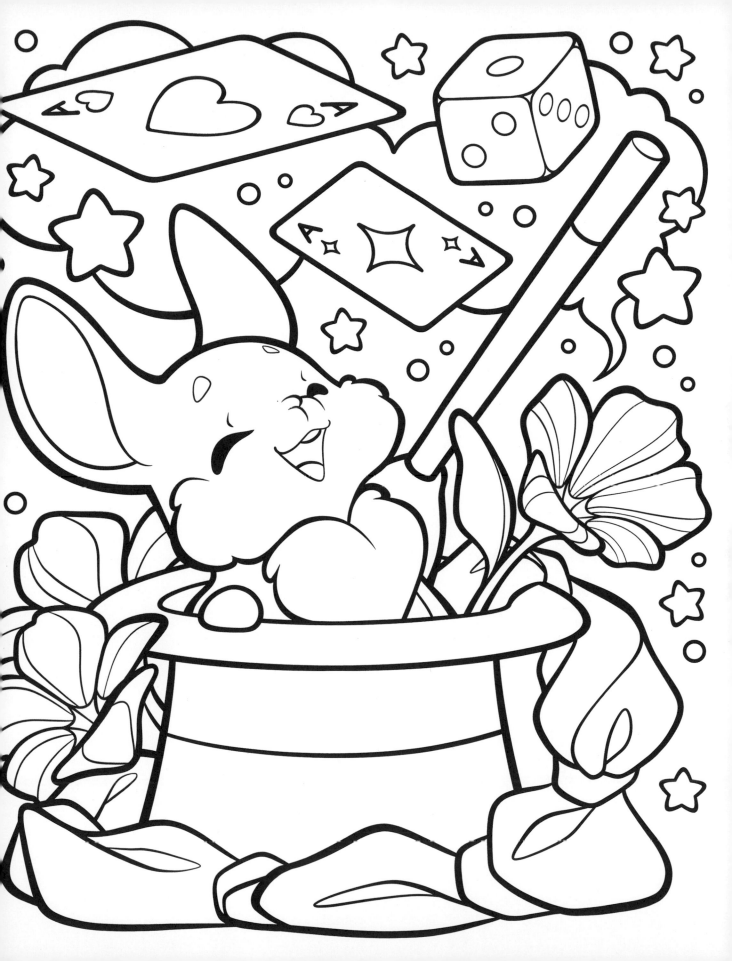

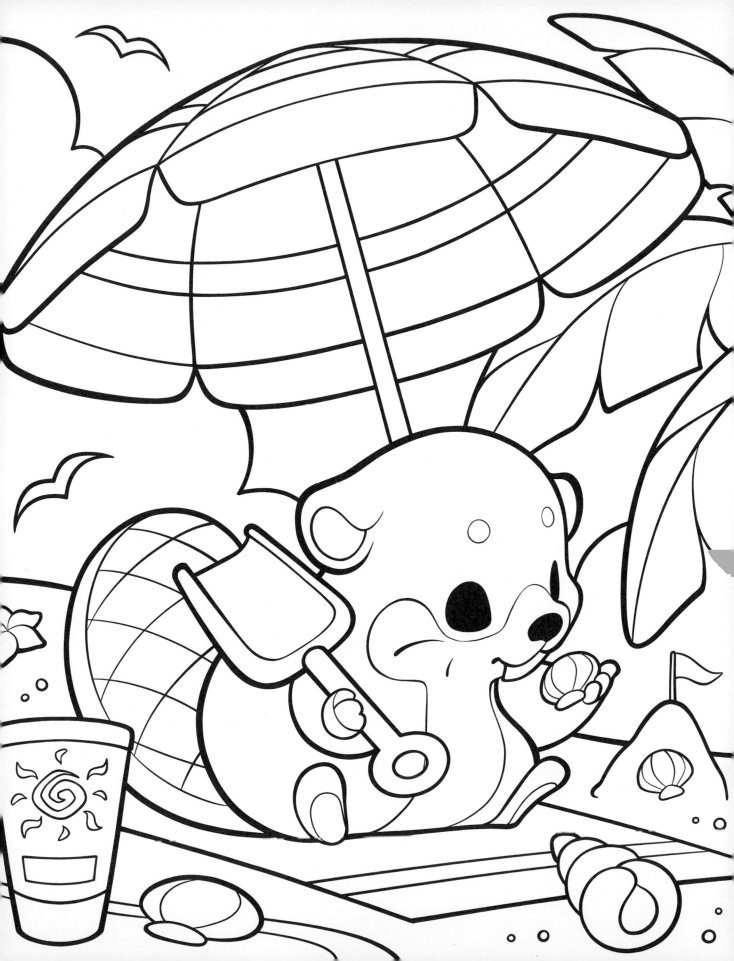

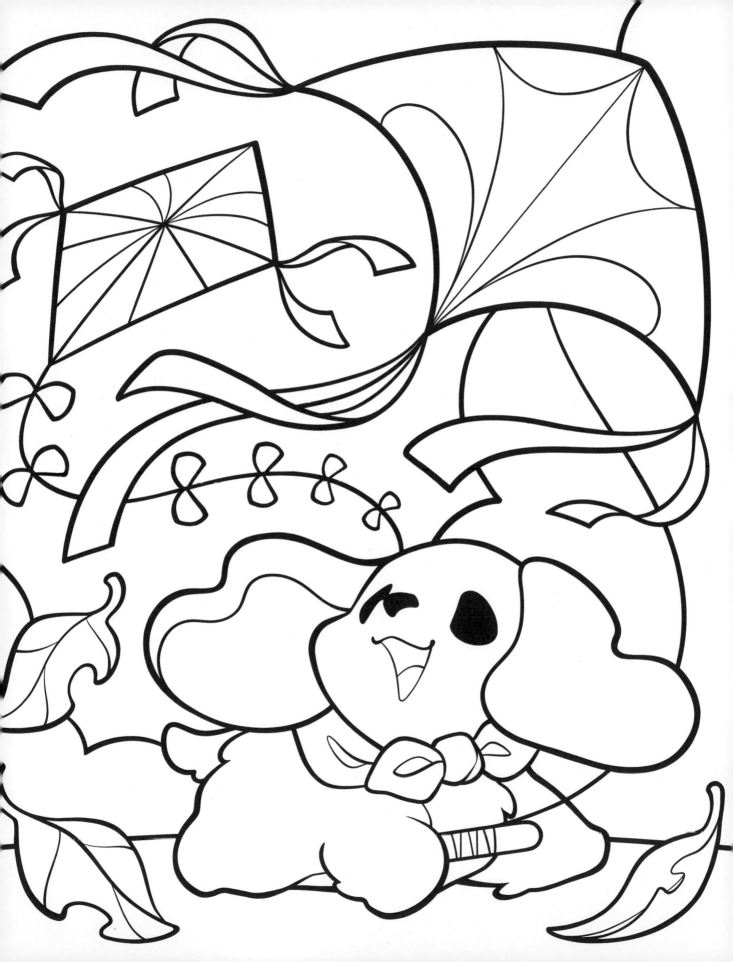

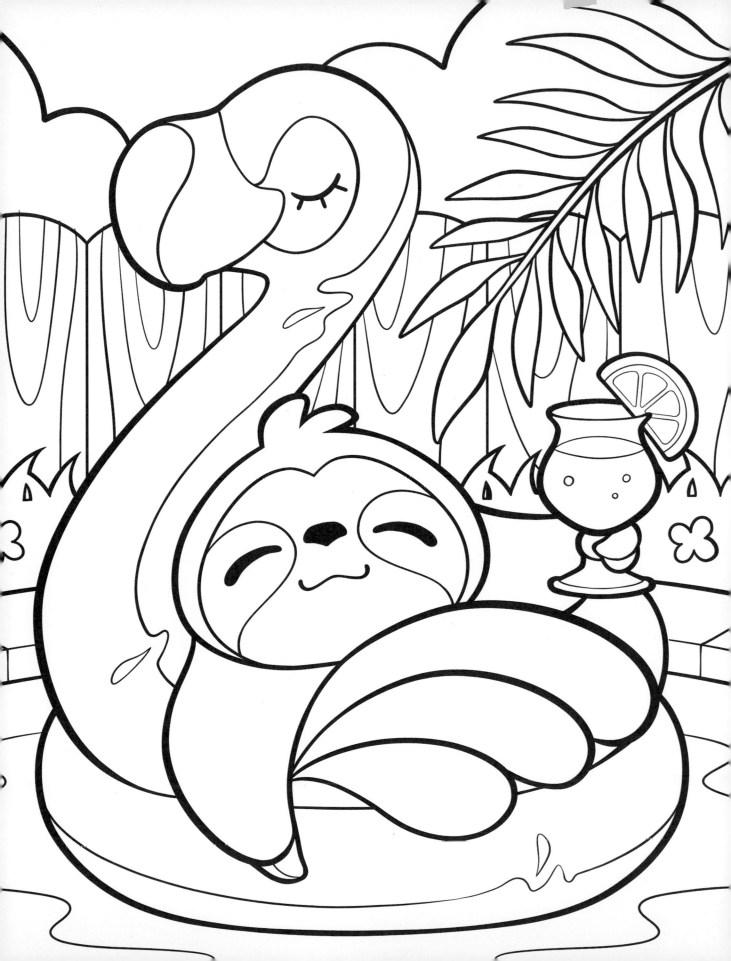

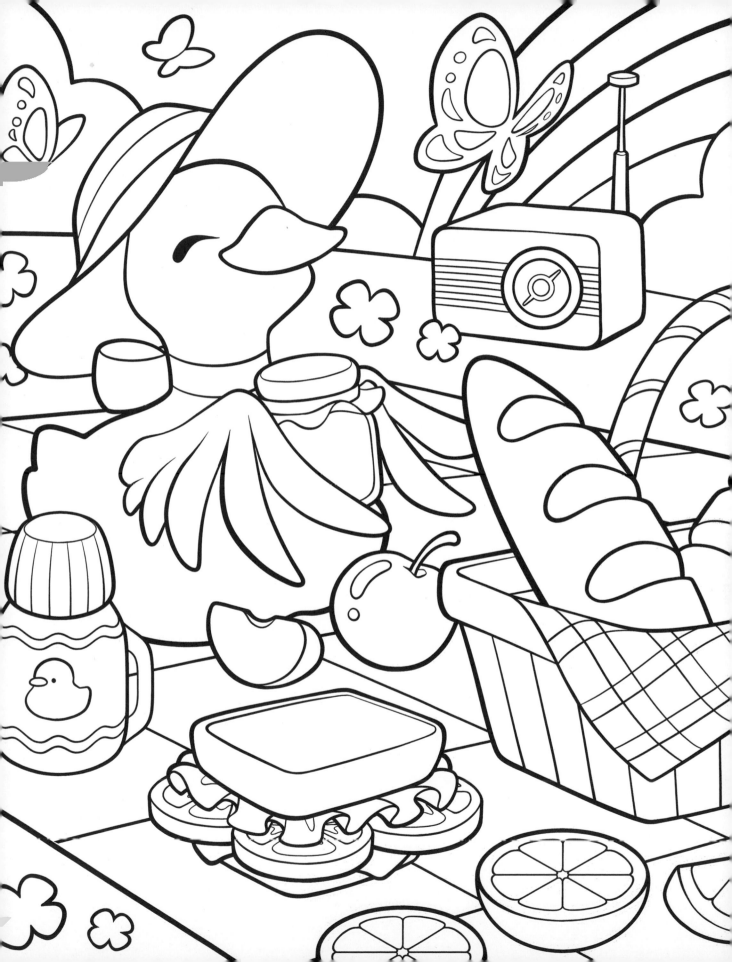

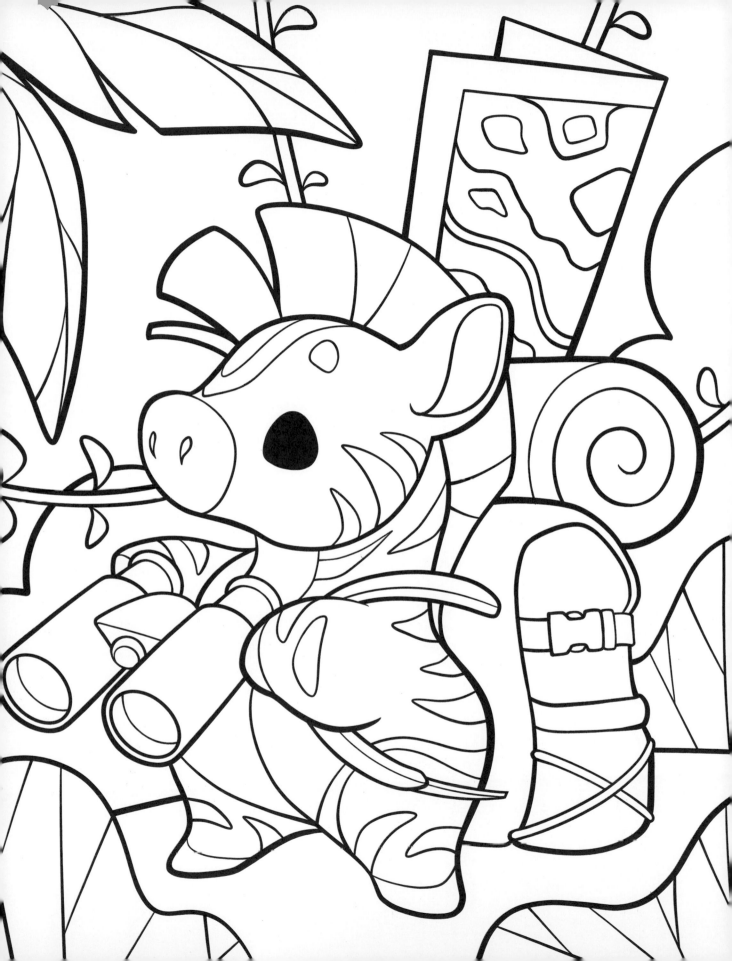

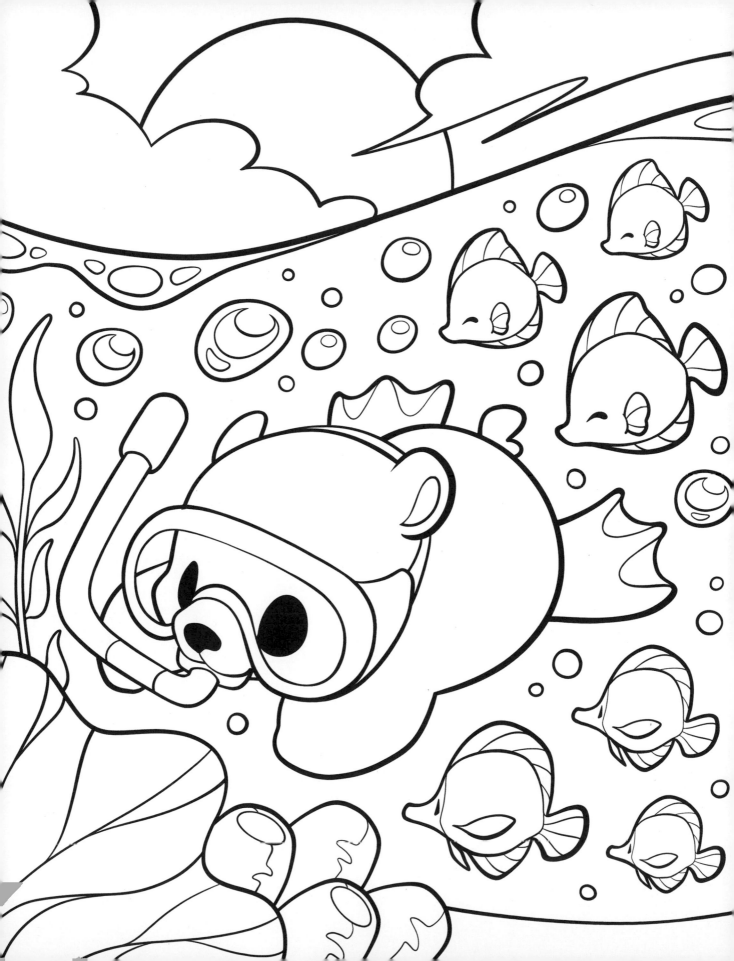

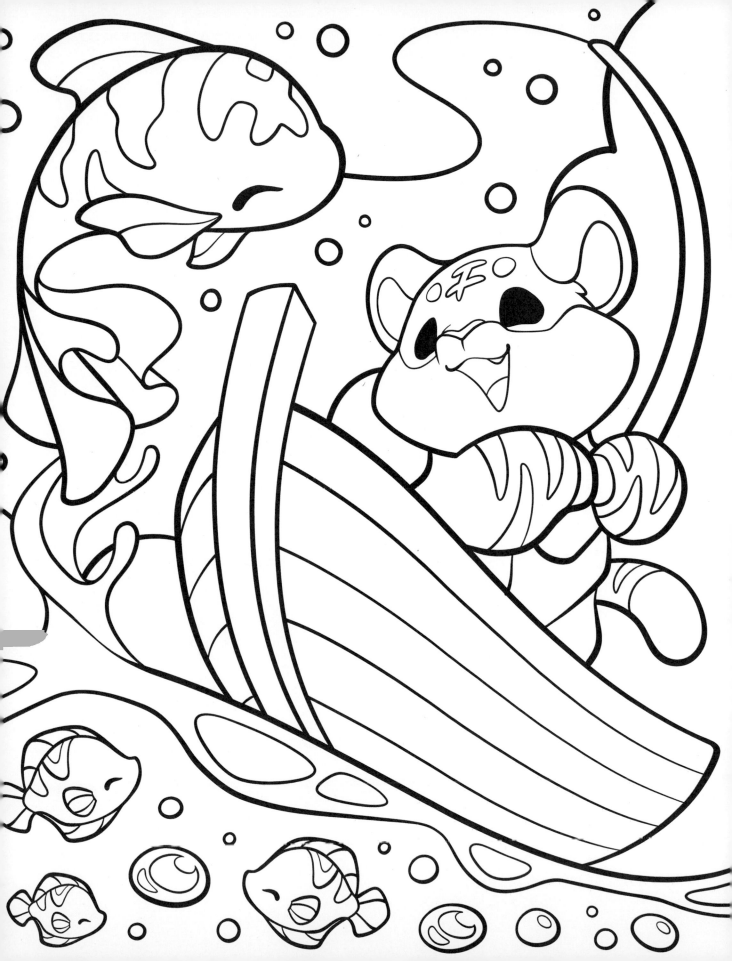

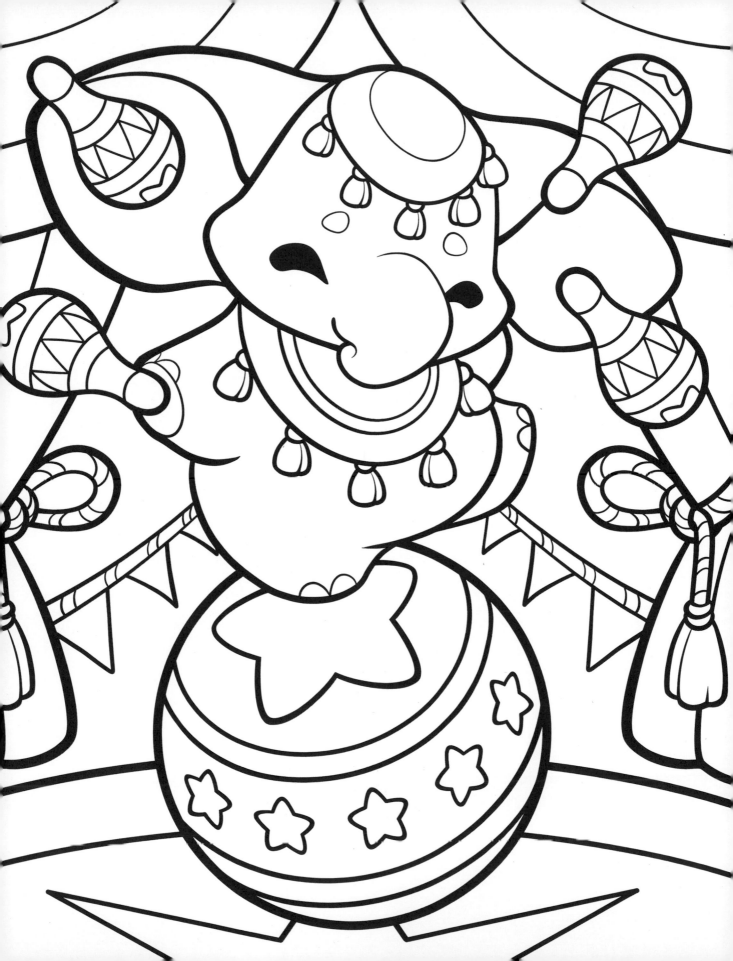

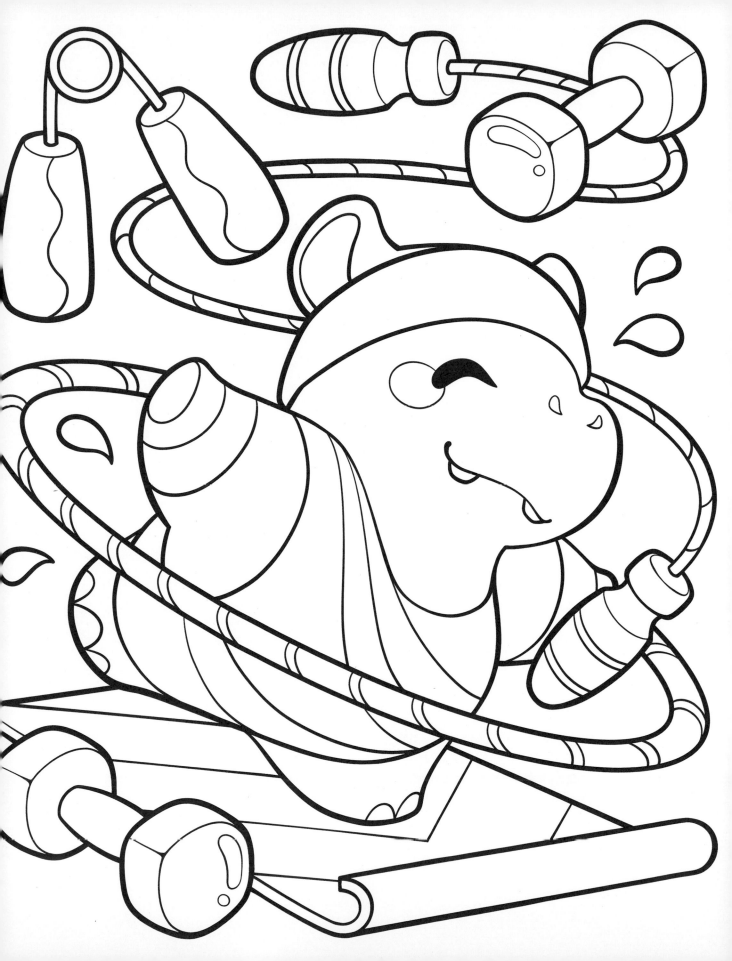

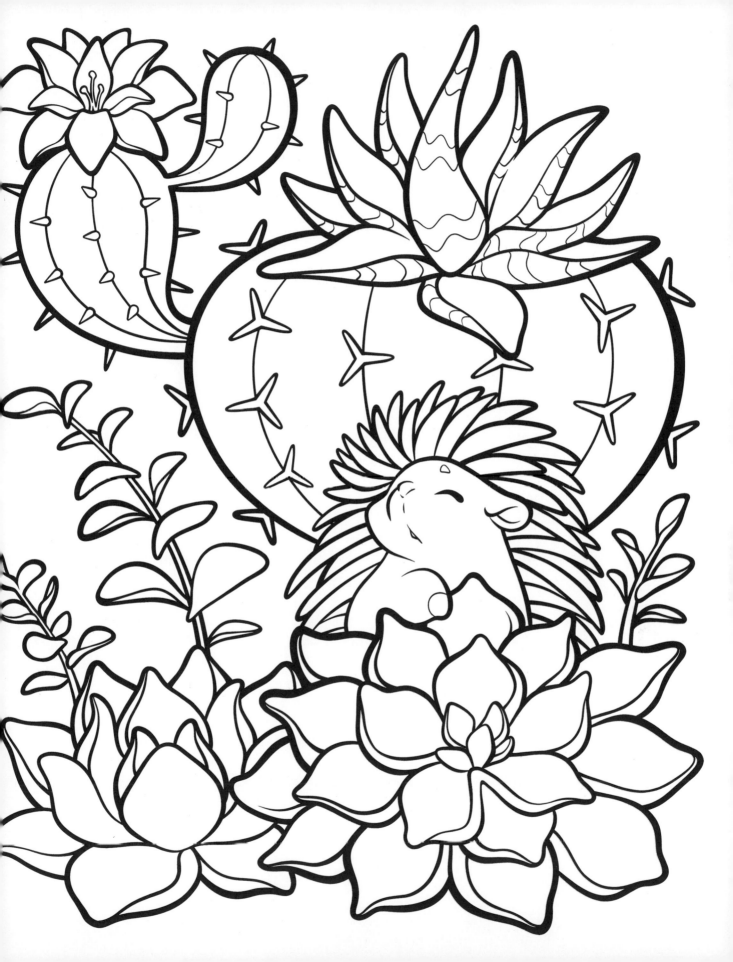

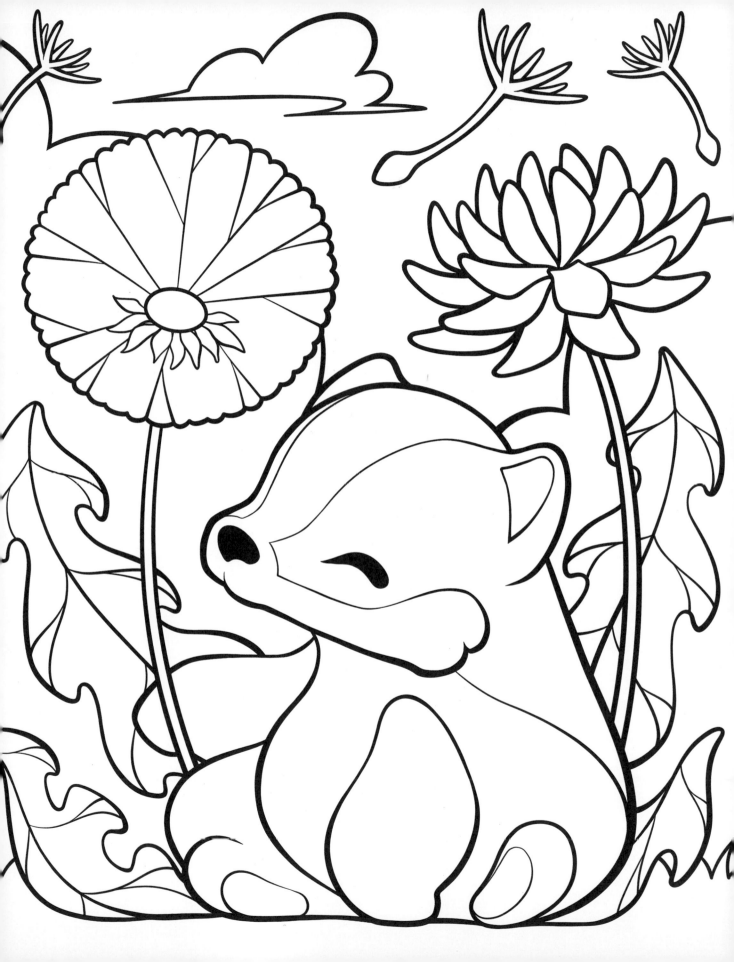

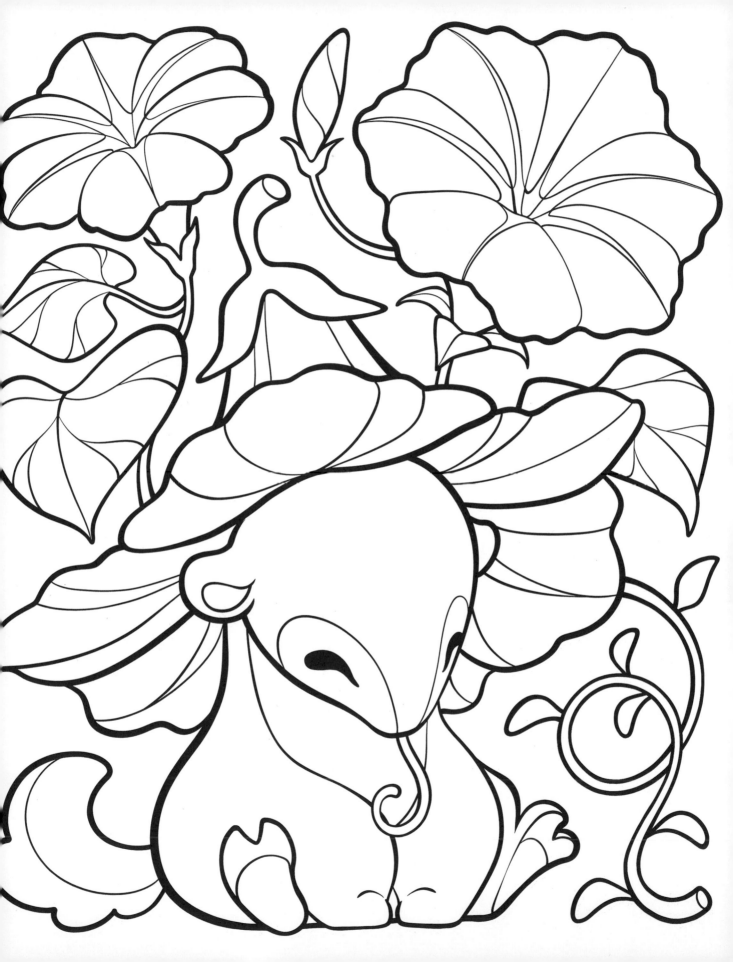

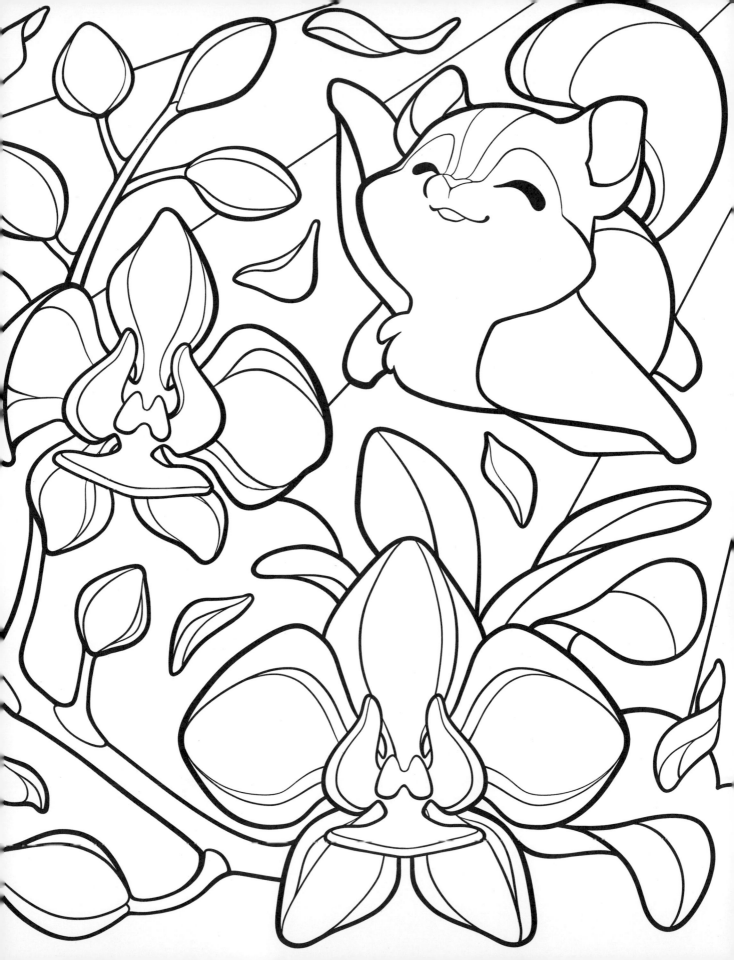

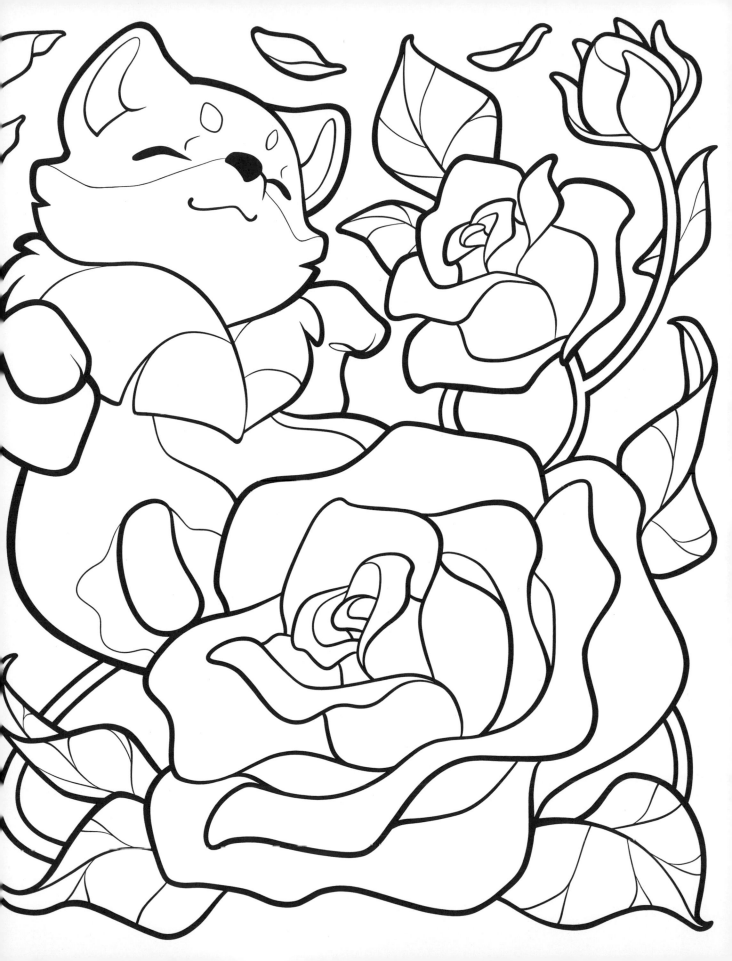

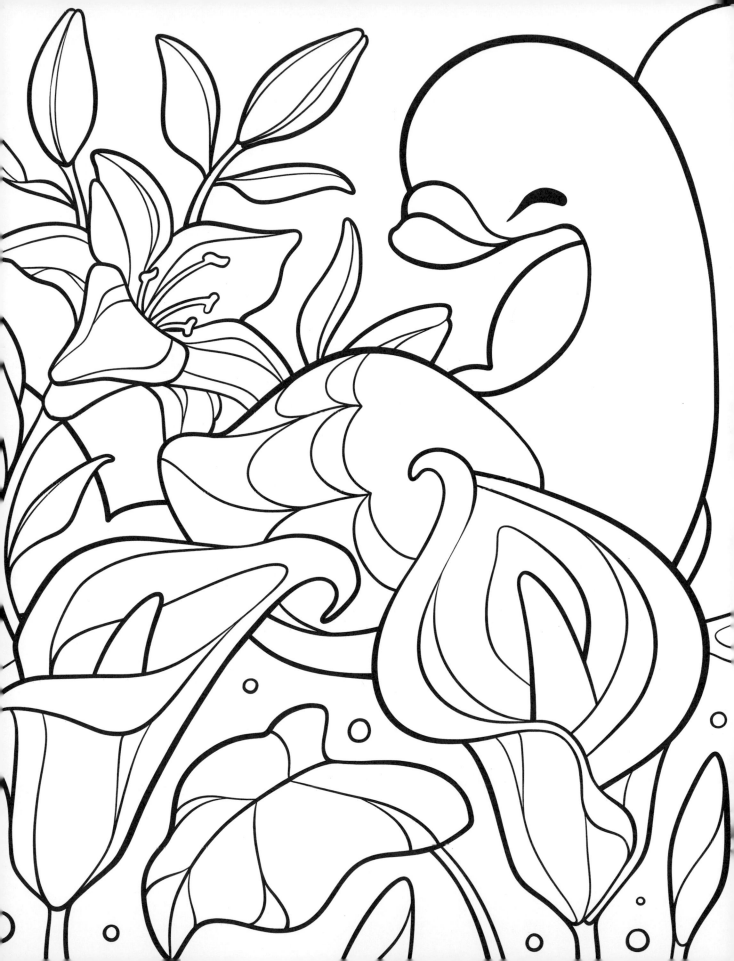

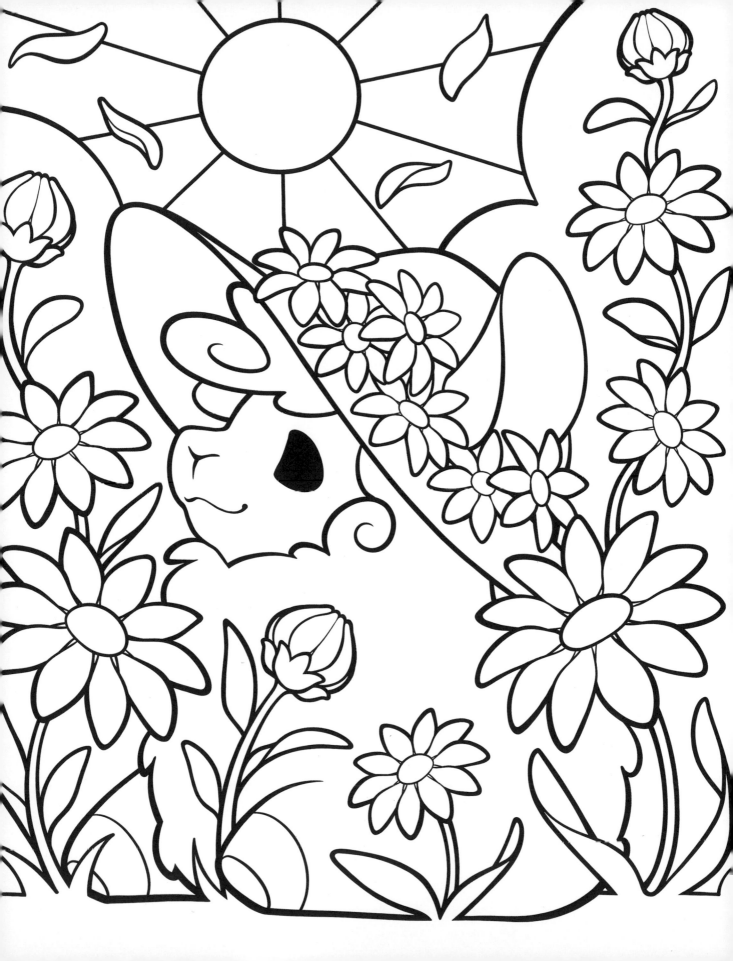

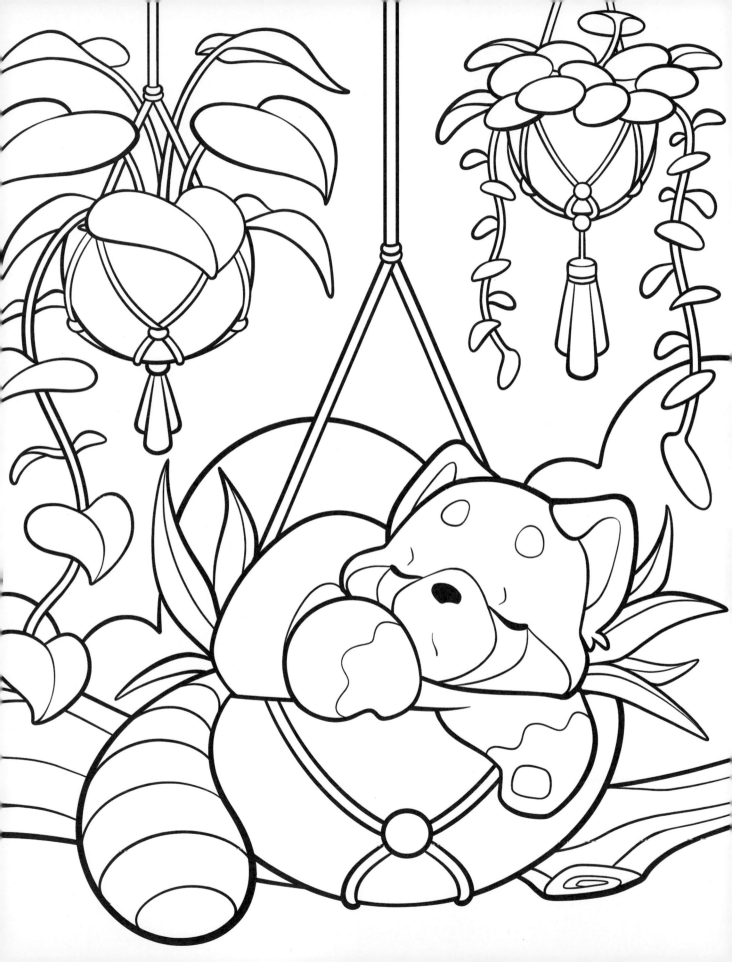

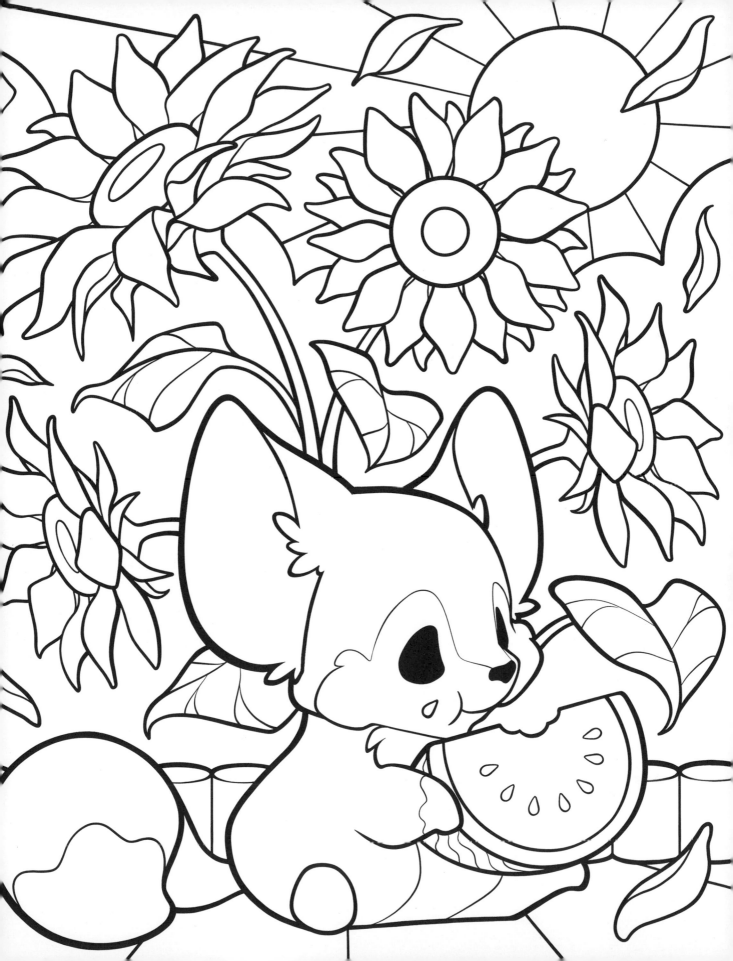

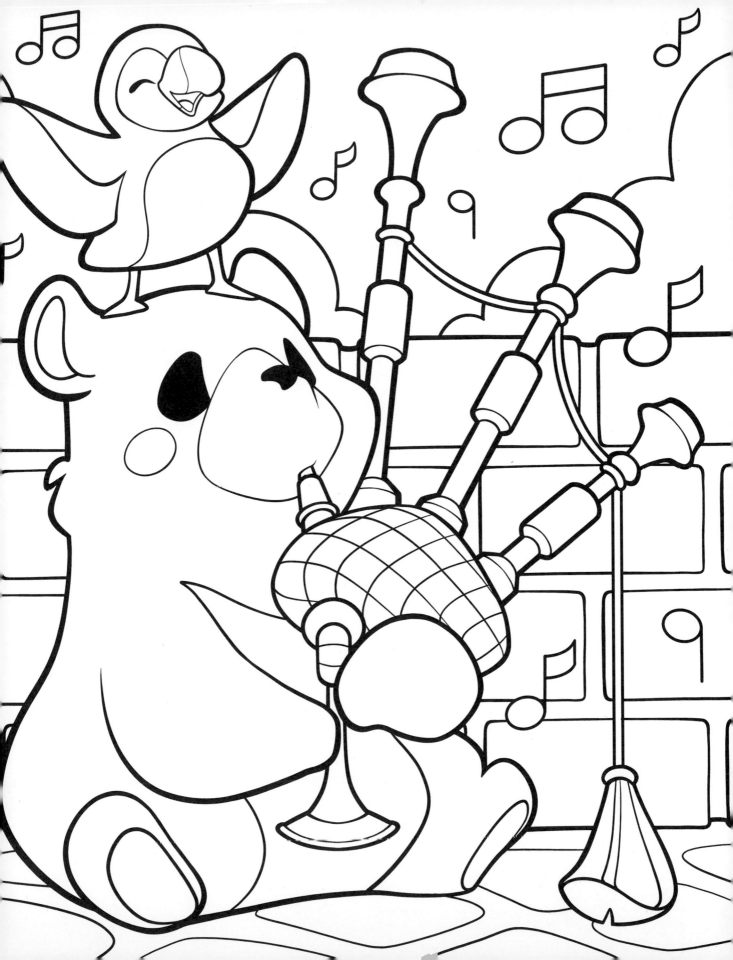

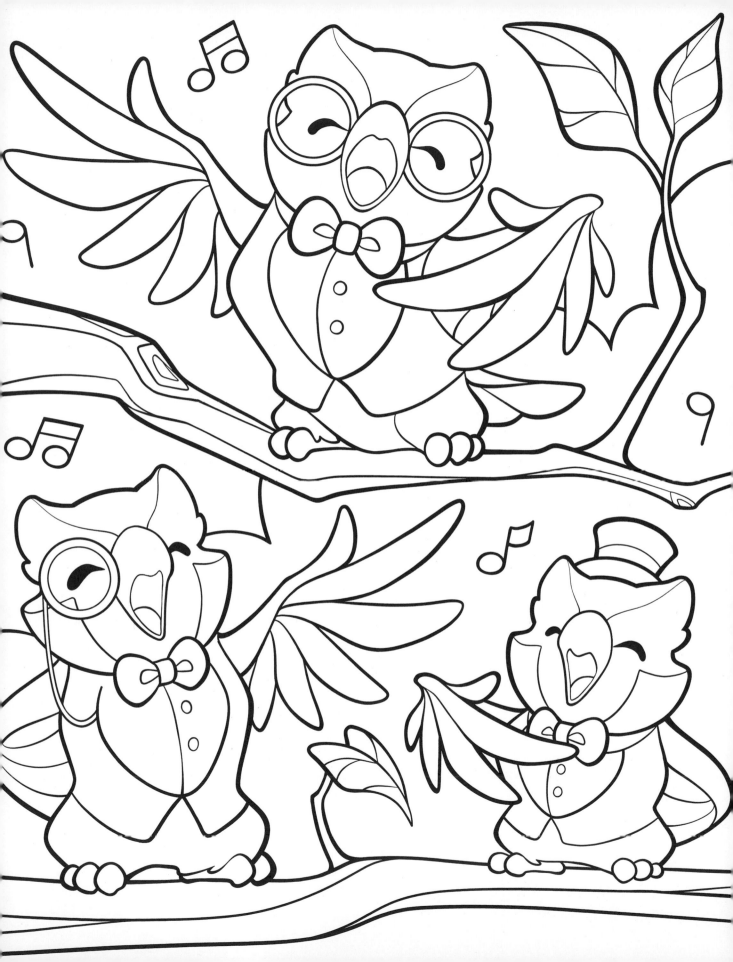

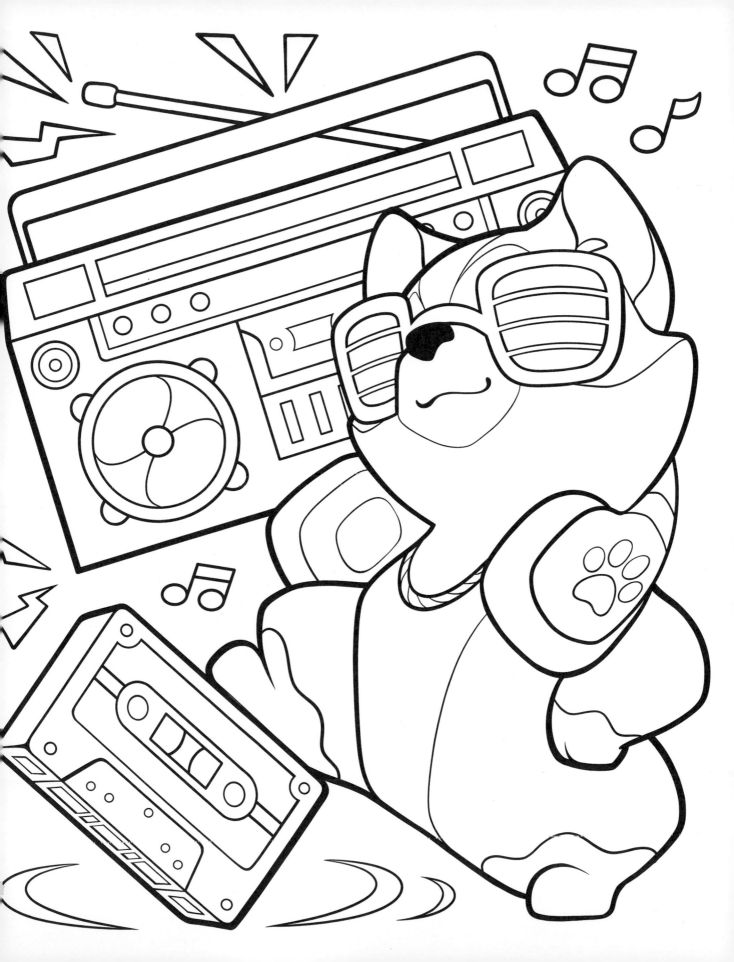

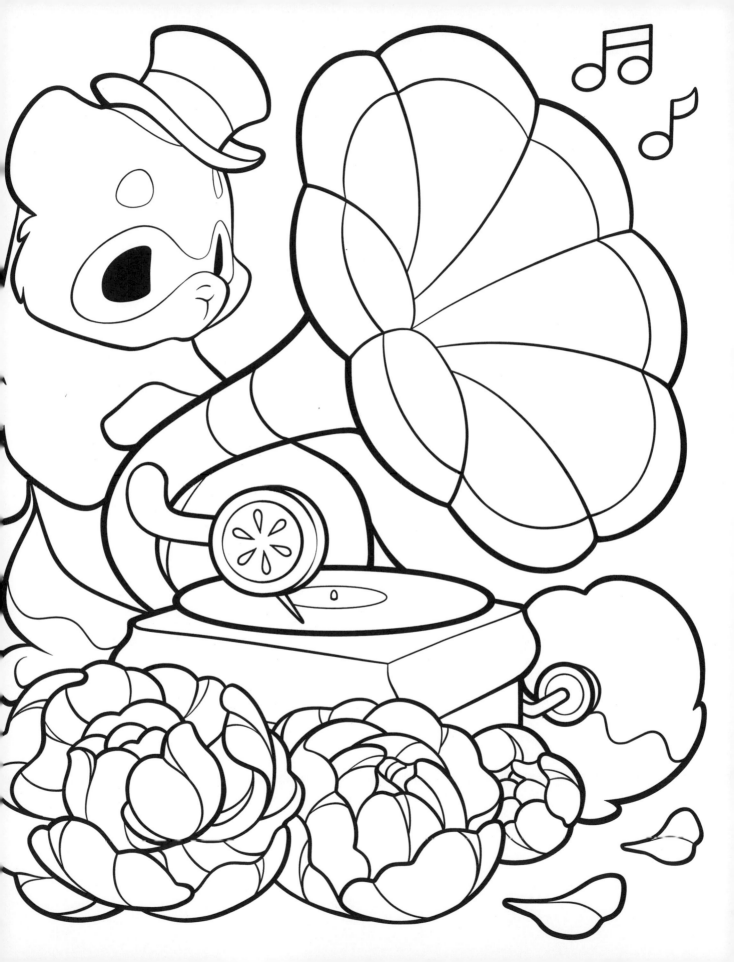

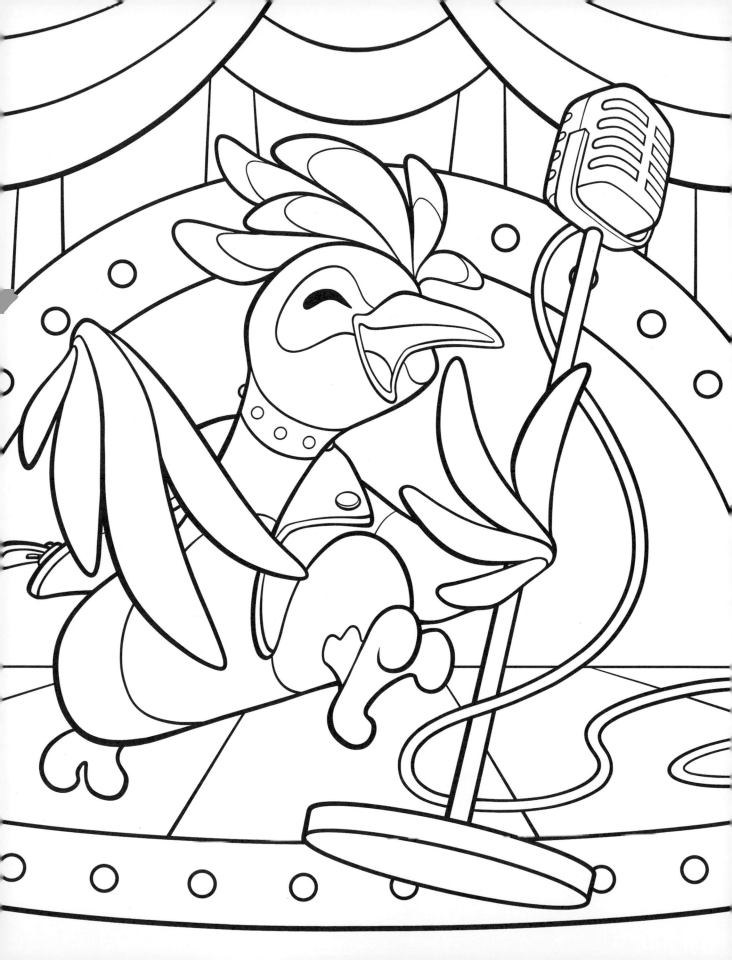

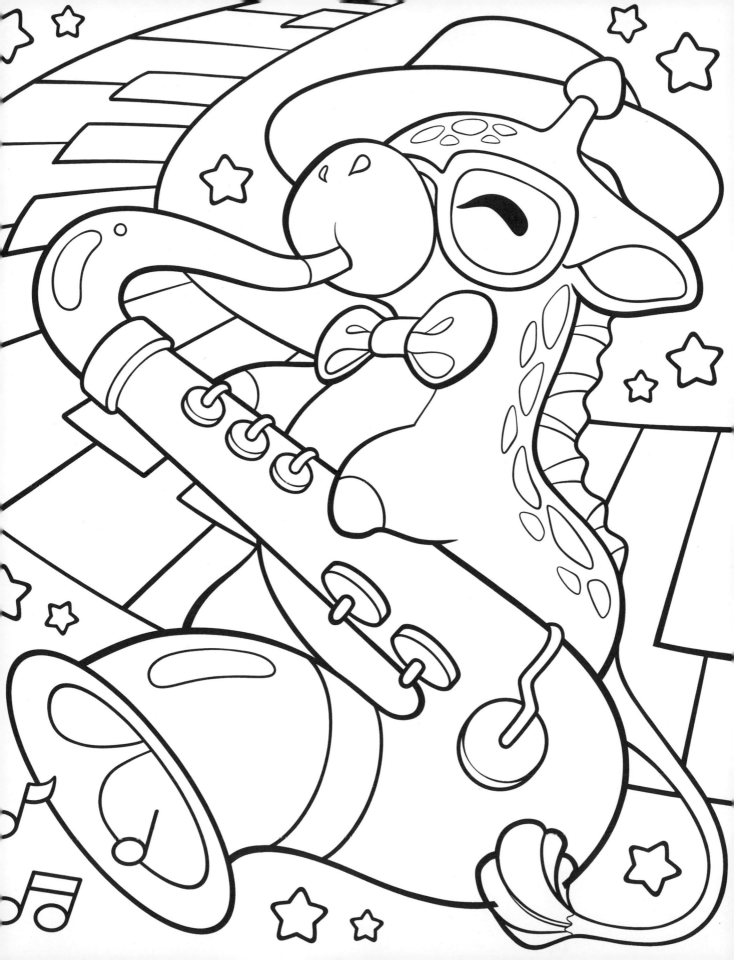

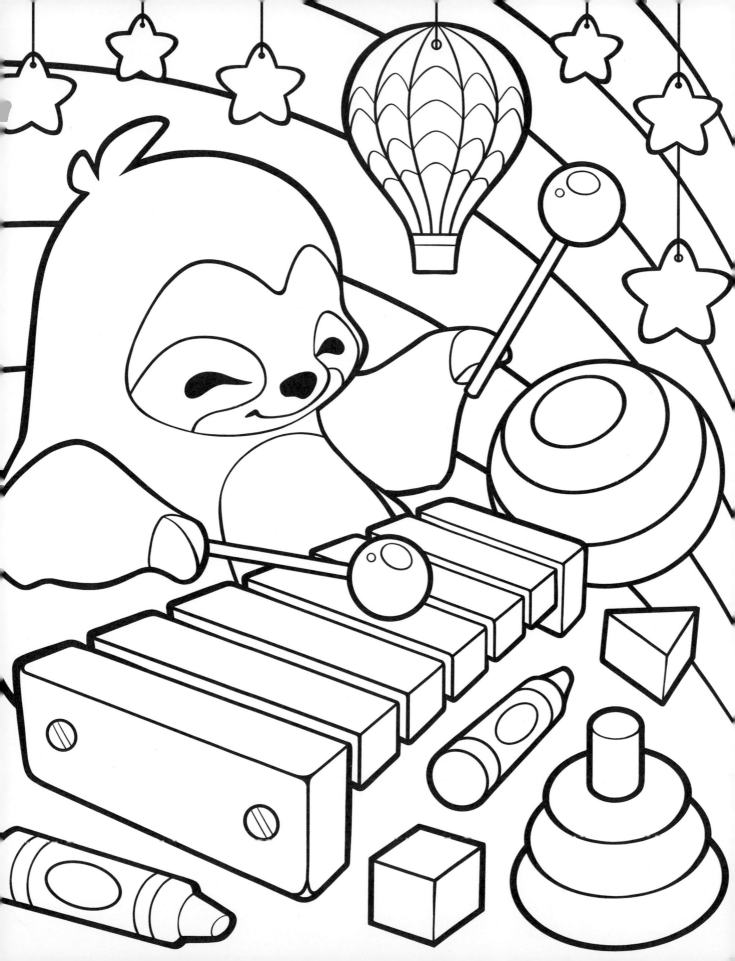

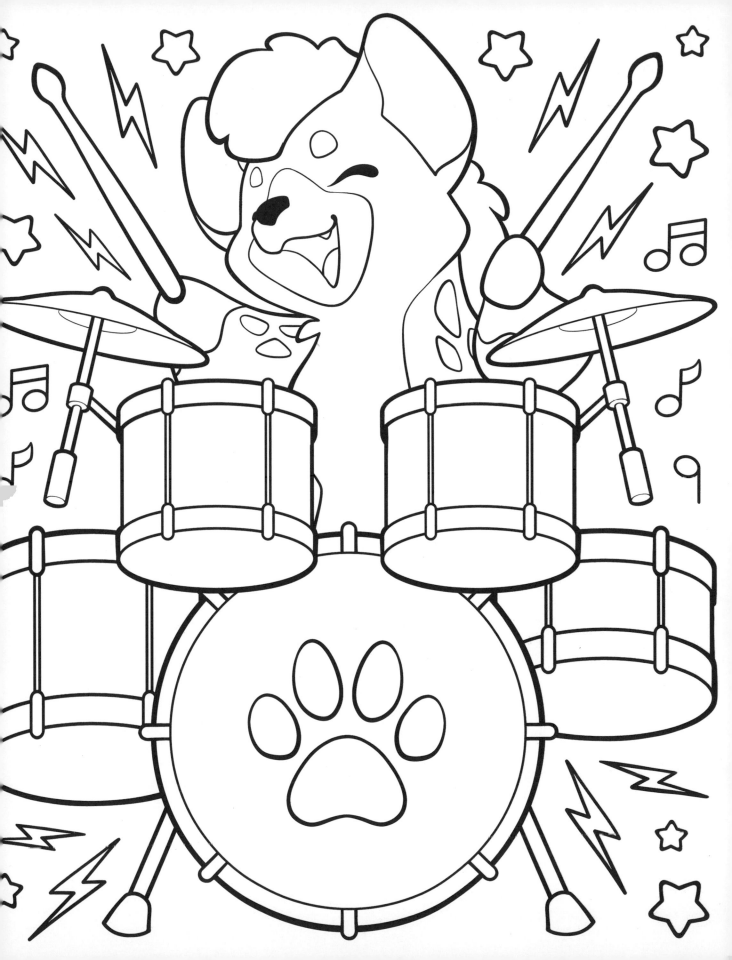

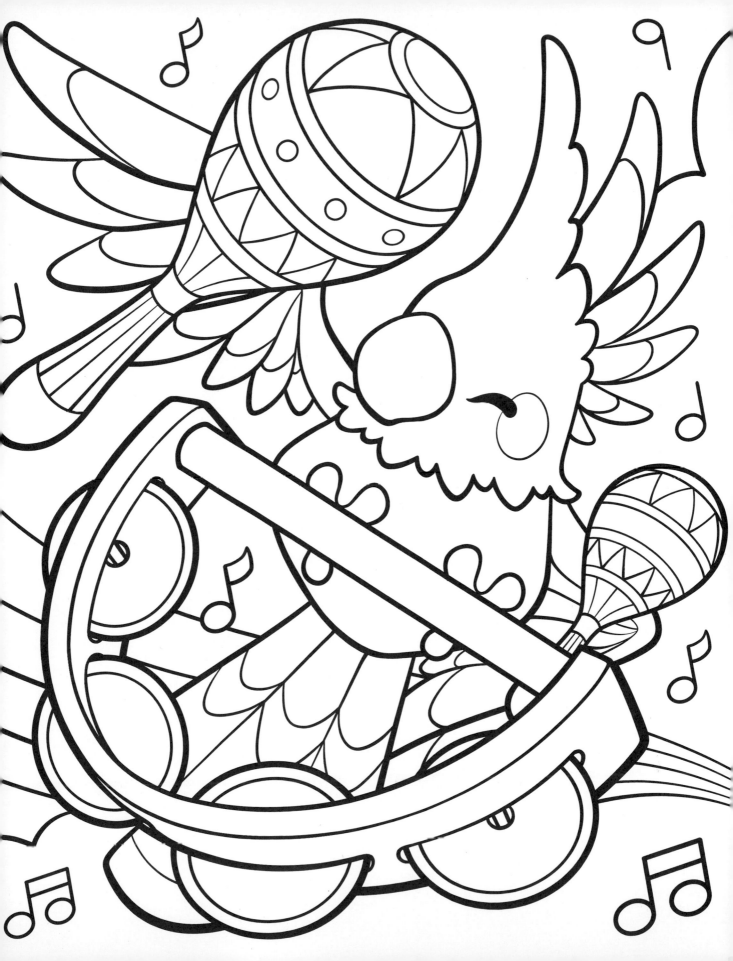

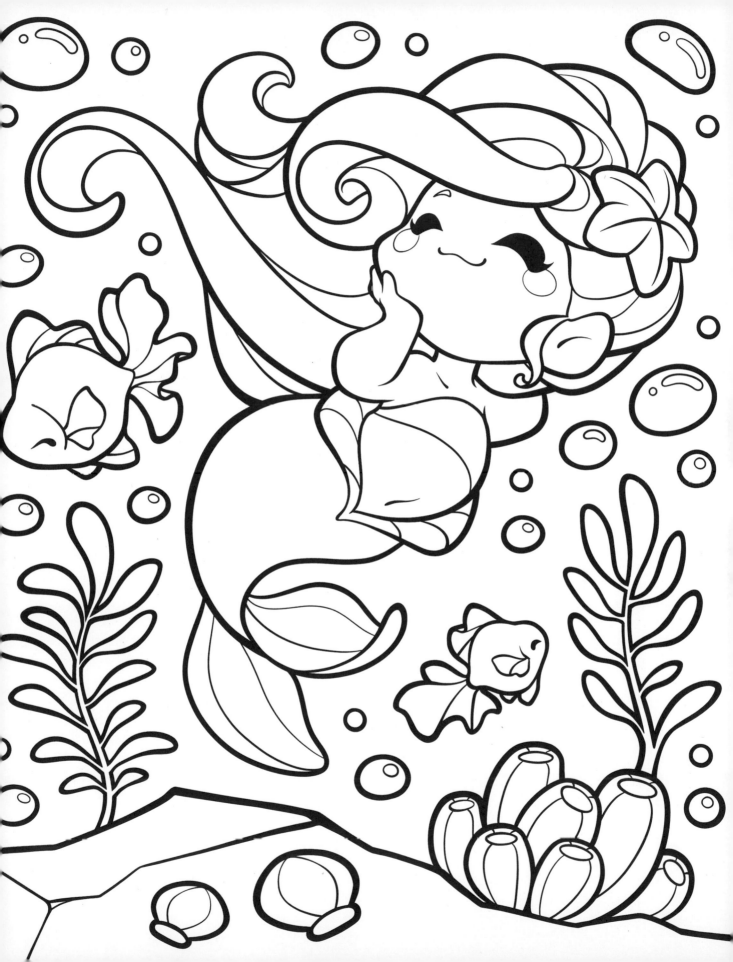

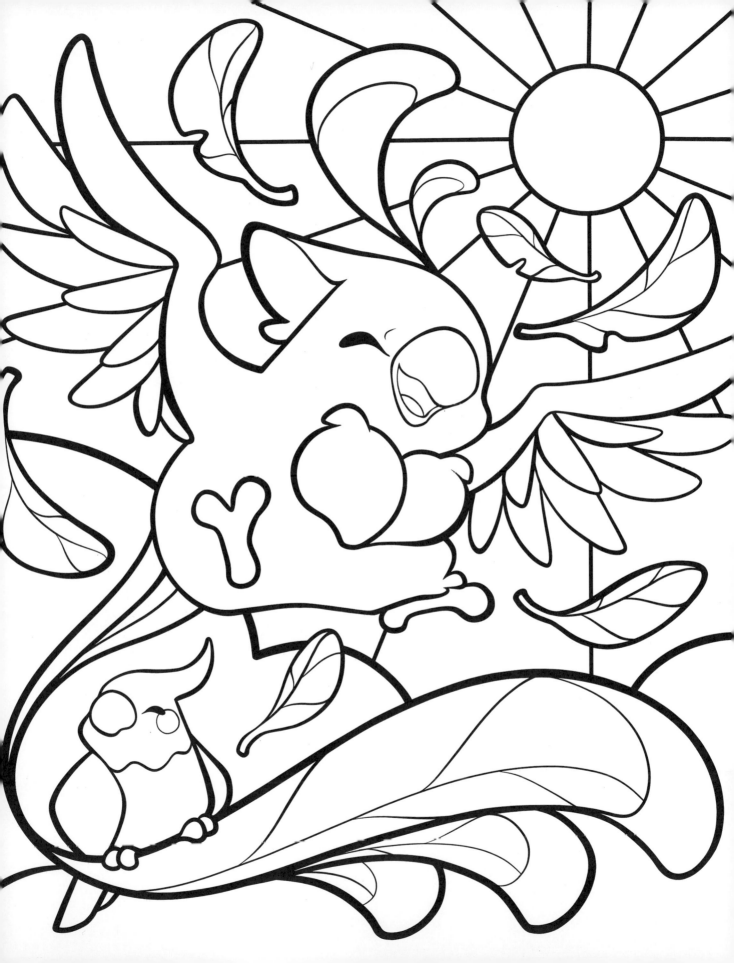

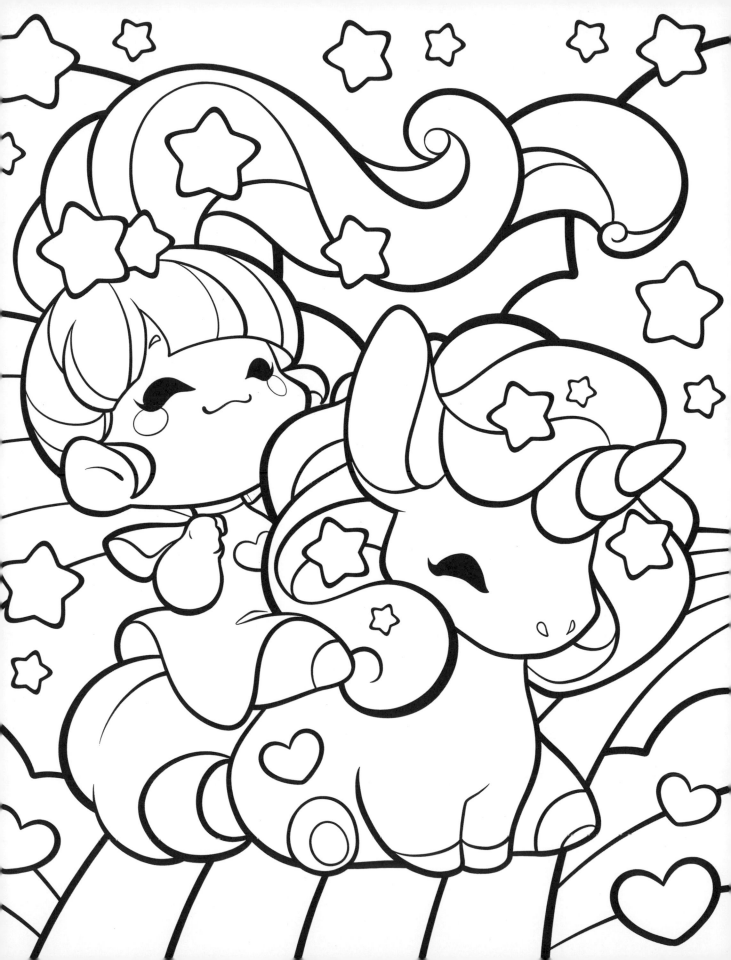

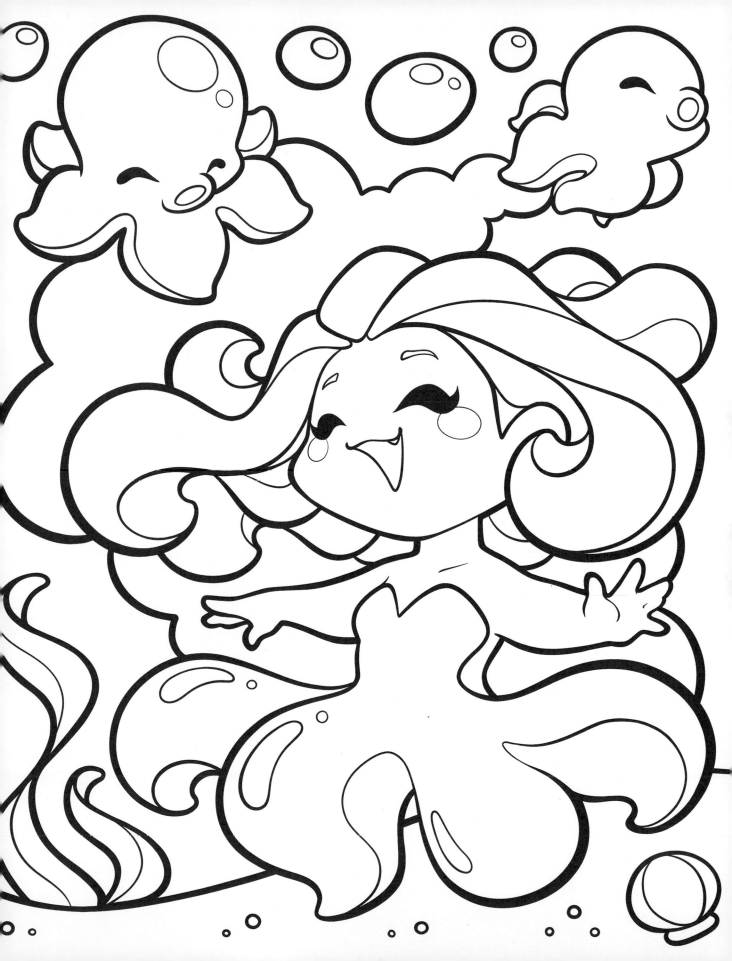

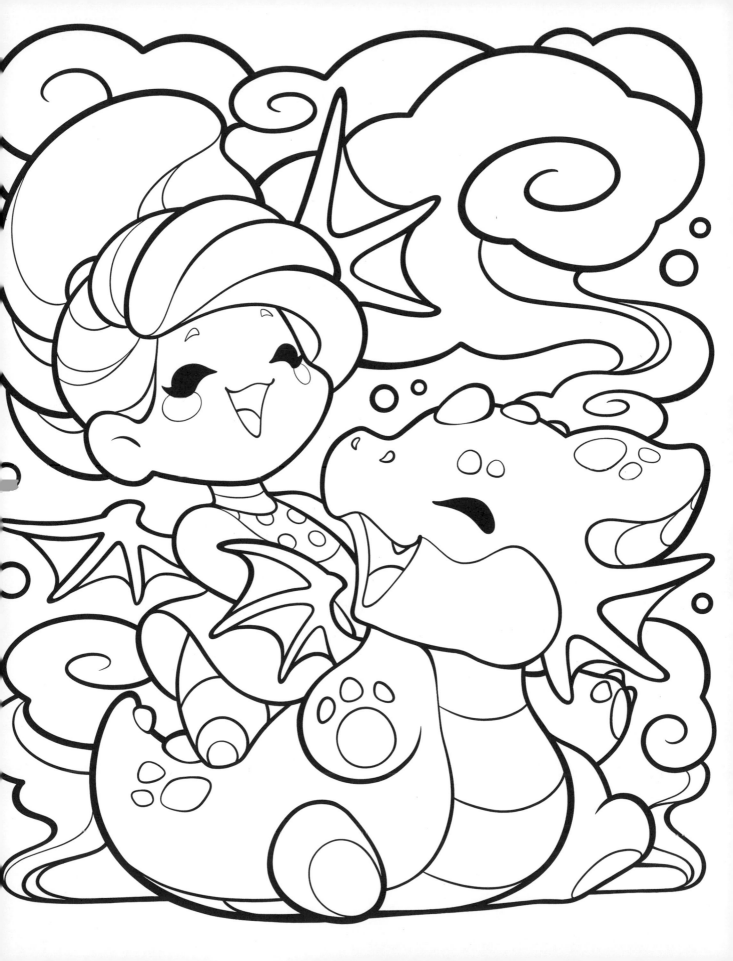

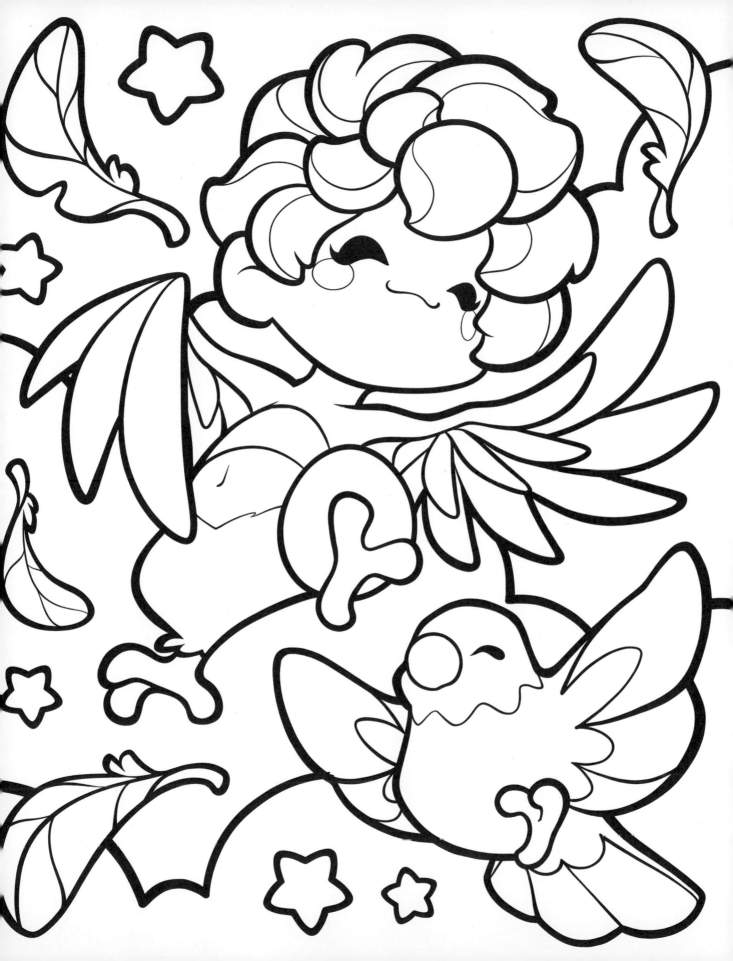

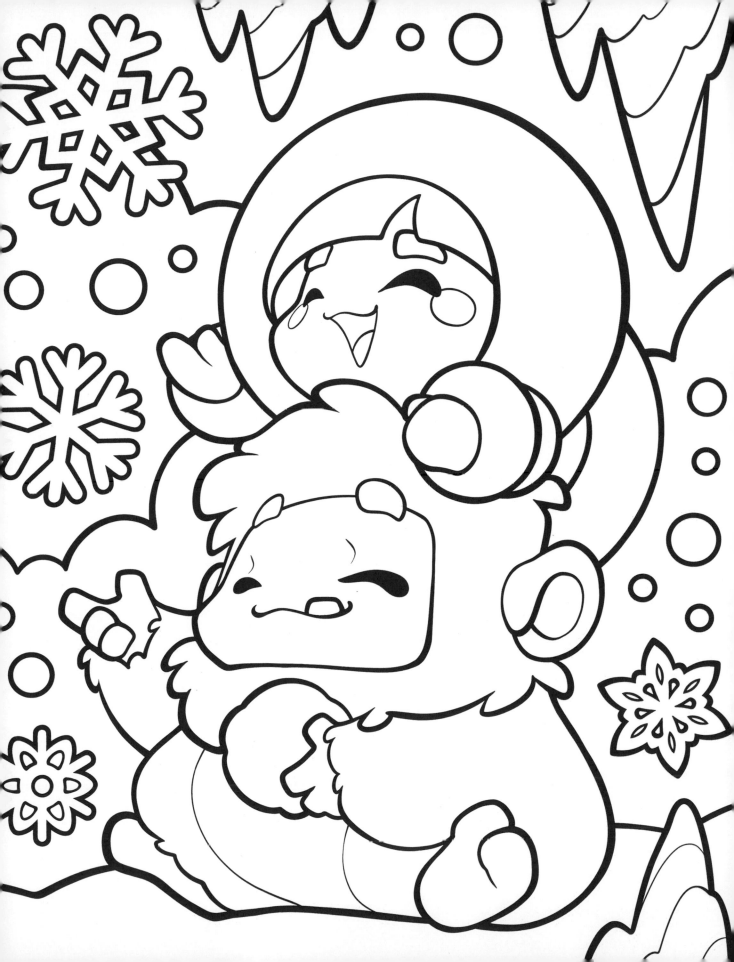

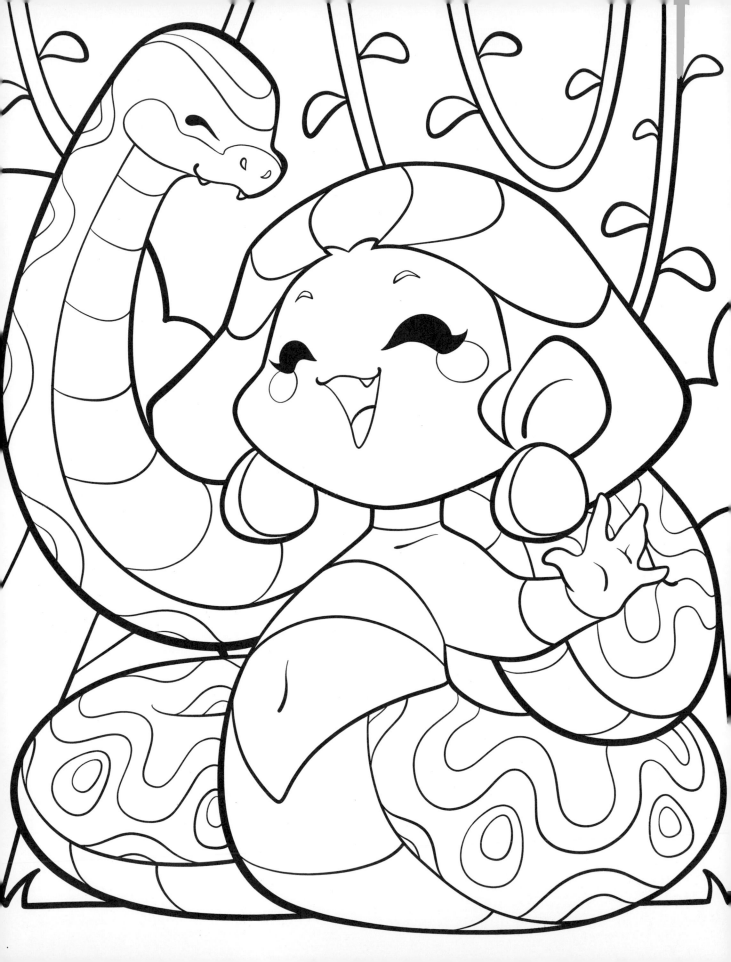

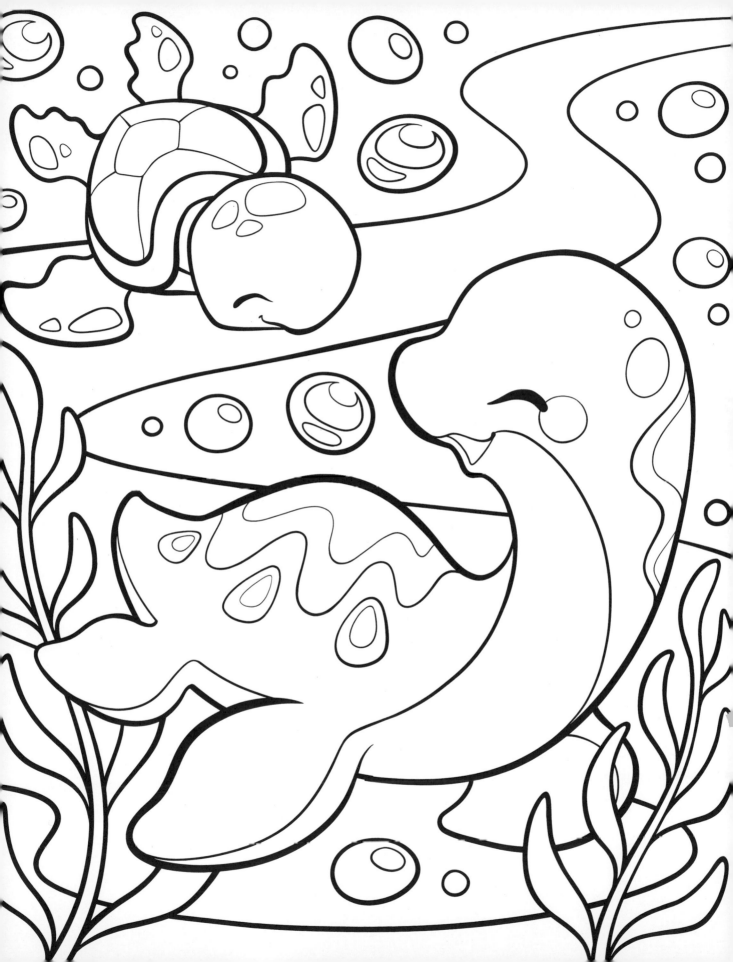

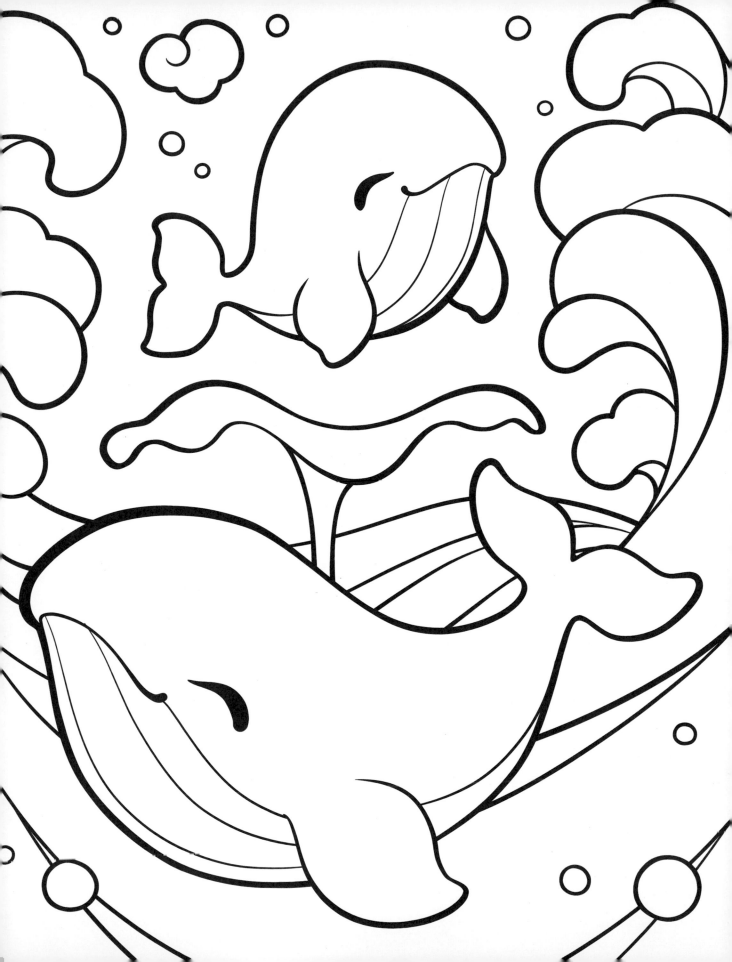

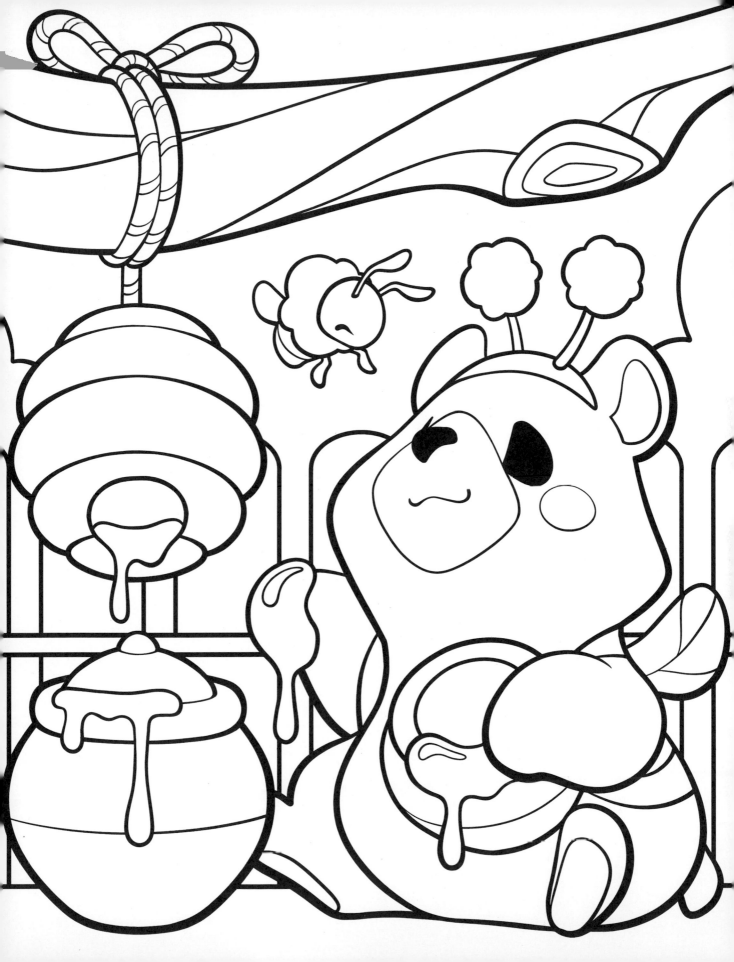

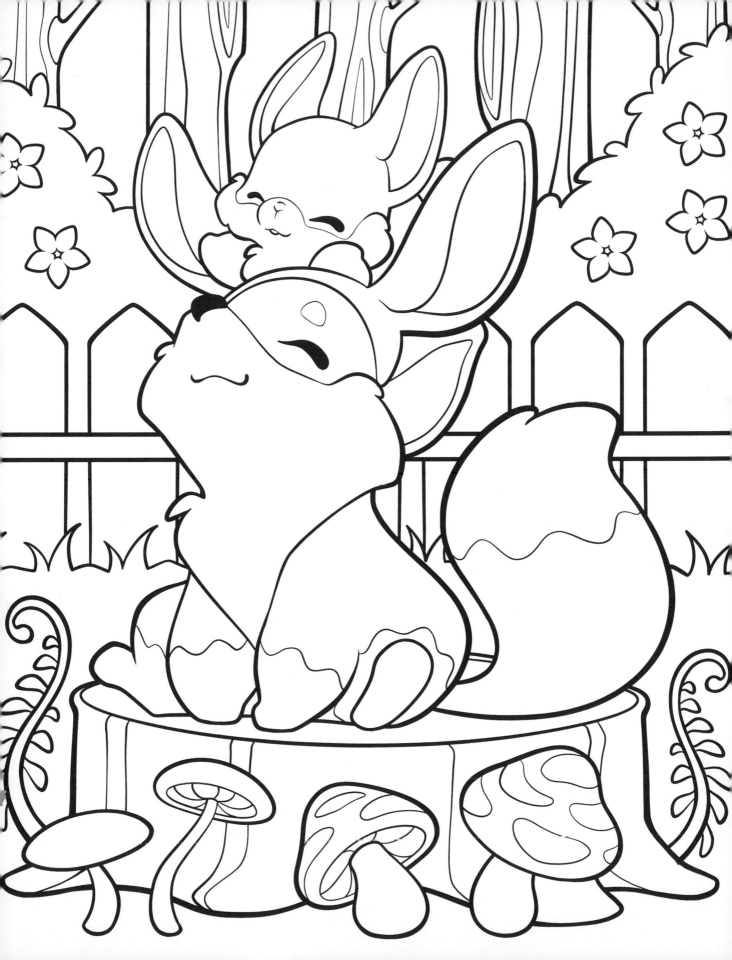

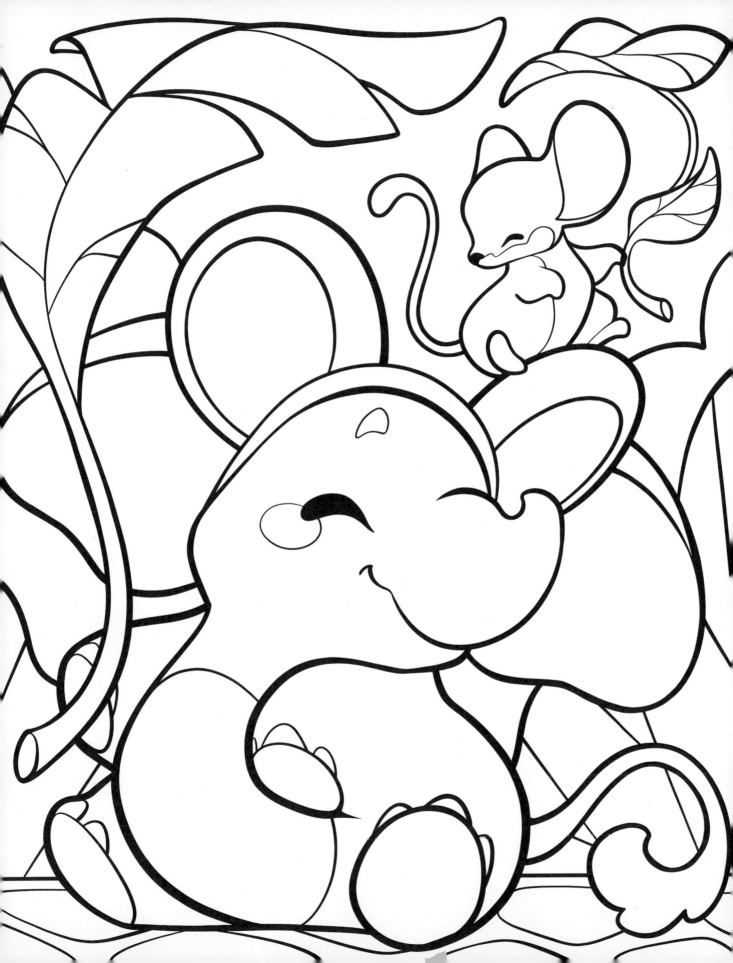

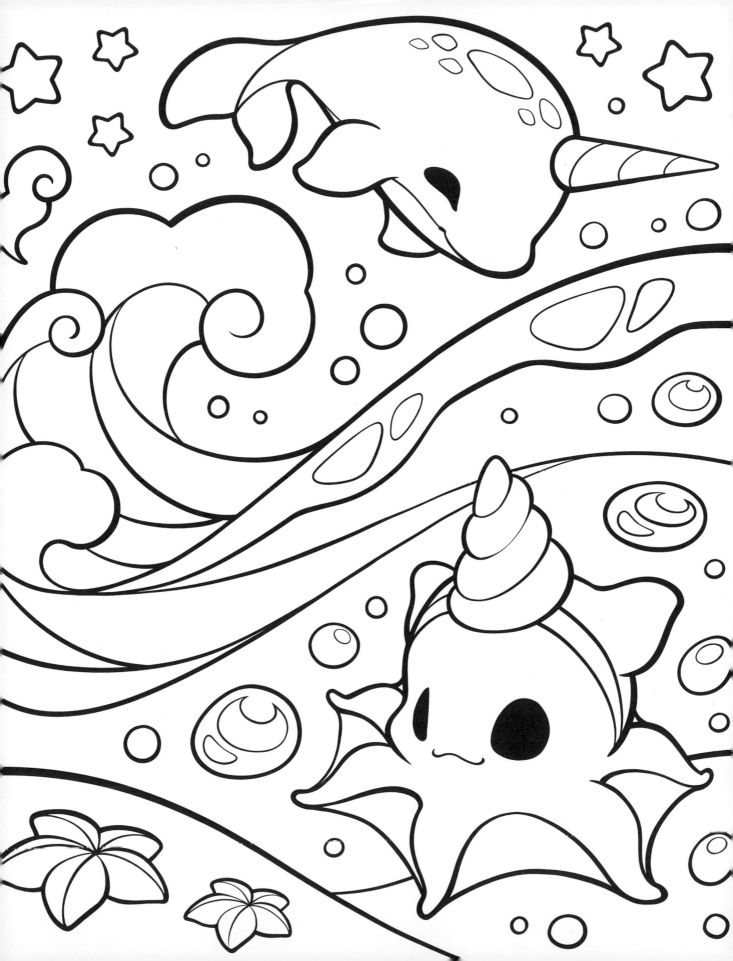

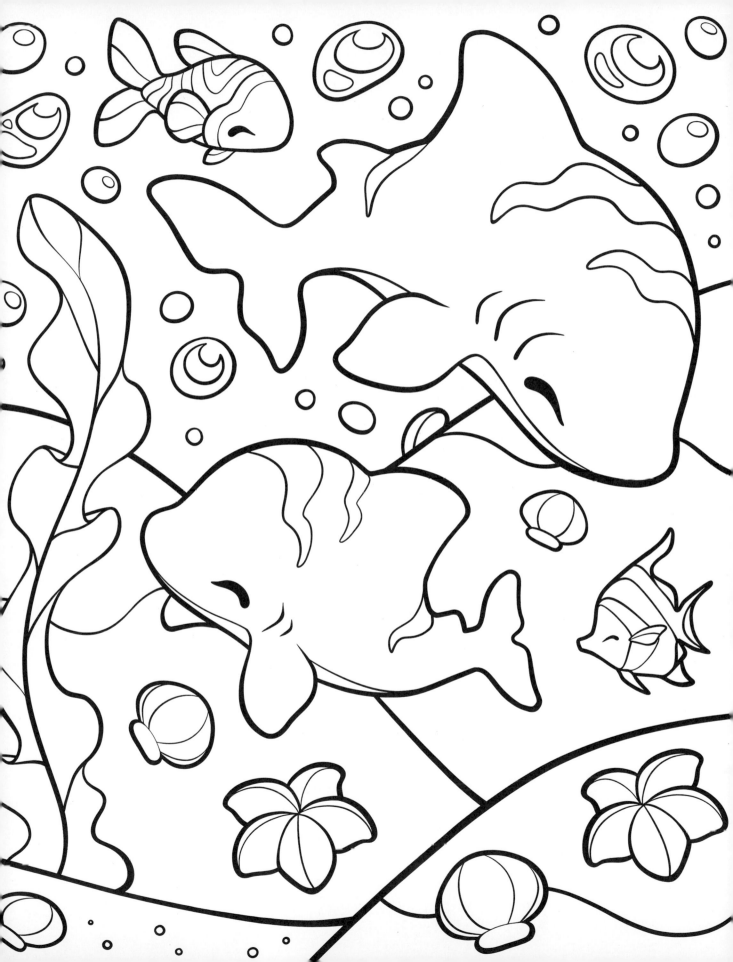

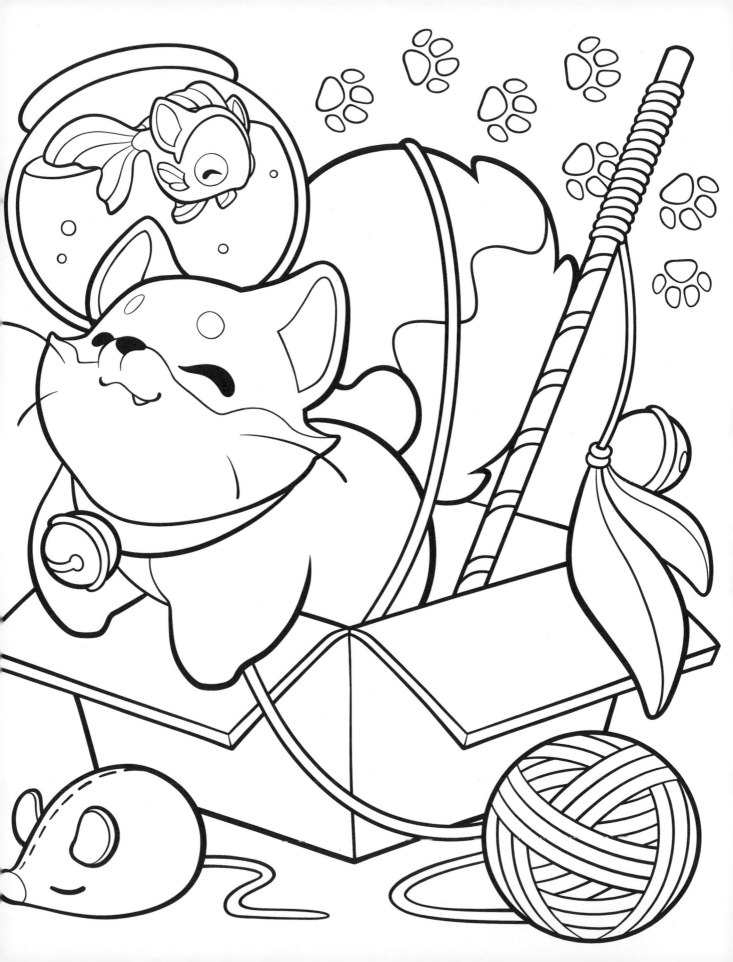

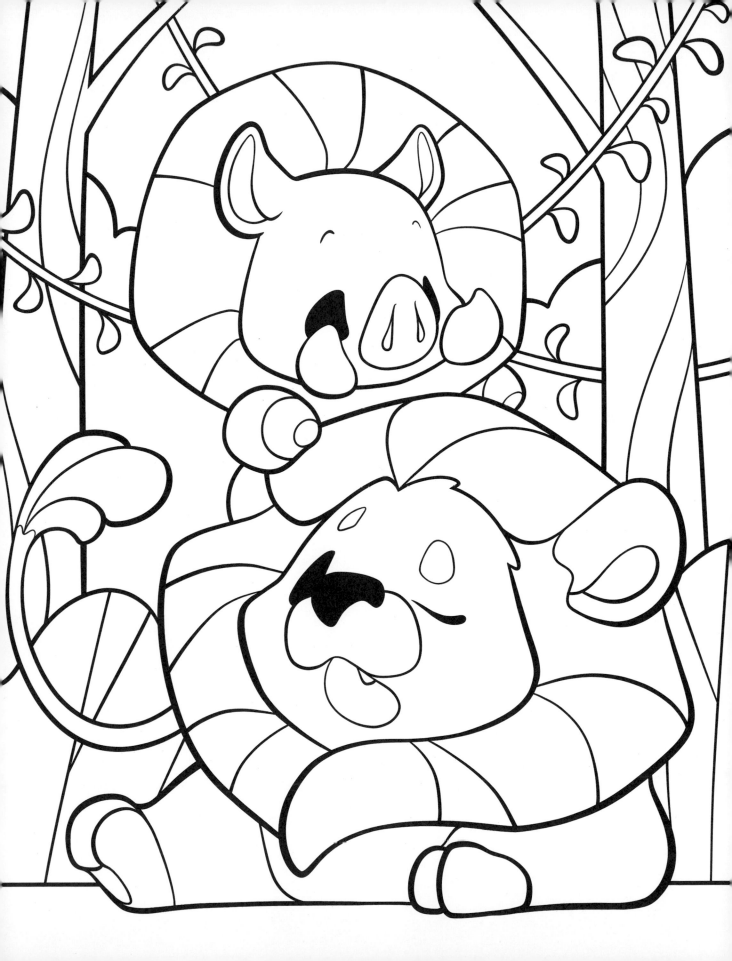

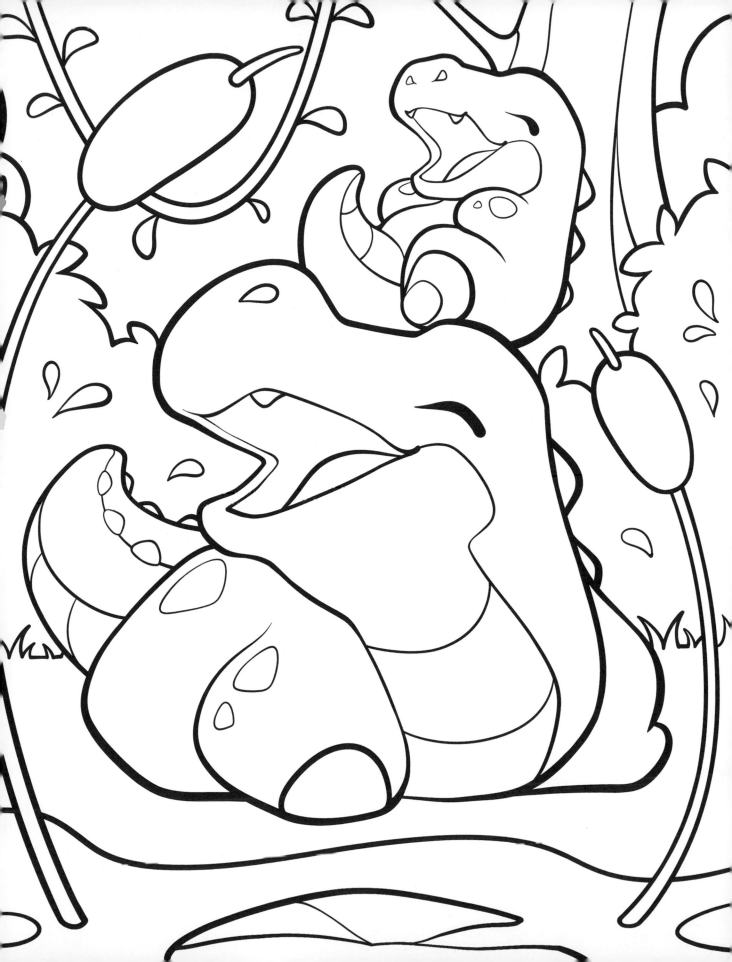

First published in 2023 by Rock Point, an imprint of The Quarto Group,
142 West 36th Street, 4th Floor, New York, NY 10018, USA
T (212) 779-4972 www.Quarto.com

Rock Point titles are also available at discount for retail, wholesale, promotional, and bulk purchase. For details,
contact the Special Sales Manager by email at specialsales@quarto.com or by mail at The Quarto Group, Attn:
Special Sales Manager, 100 Cummings Center Suite 265D, Beverly, MA 01915 USA.

10 9

ISBN: 978-1-63106-939-0

Publisher: Rage Kindelsperger
Creative Director: Laura Drew
Managing Editor: Cara Donaldson
Editor: Sara Bonacum
Cover and Interior Design: Beth Middleworth

Printed in China